IMAGES
of America

THE CASCO
BAY ISLANDS
1850–2000

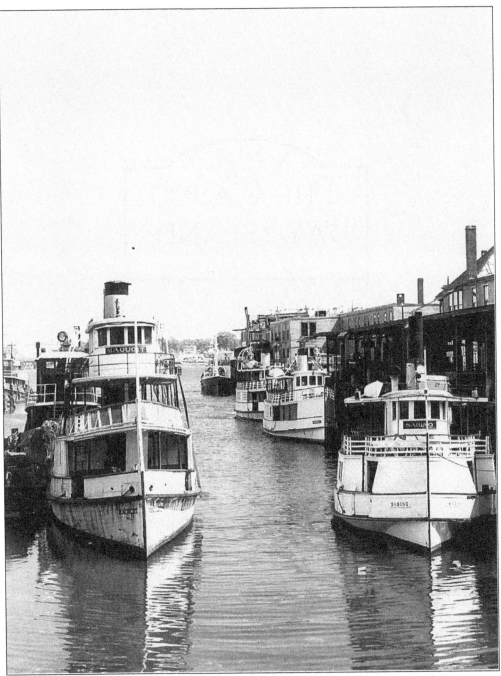

The ferries are the lifeline to the islands, and island residents and visitors share the passage to and from Portland. Shuttling groceries, goods, children, pets, and bicycles on and off the boats encourages islanders to meet and stay in touch with one another from day to day. Casco Bay Lines and its predecessors have provided service to the islands for over 150 years. Of the three steamboats pictured above, the *Maquoit*, the *Tourist*, and the *Sabino*, only the *Sabino* is still running; she provides pleasure cruises on the Thames River from her home port of Mystic, Connecticut. (Author's collection.)

IMAGES
of America

THE CASCO
BAY ISLANDS
1850–2000

Kimberly E. MacIsaac

ARCADIA
PUBLISHING

Published by Arcadia Publishing
Charleston, South Carolina

Library of Congress Catalog Card Number: 2004106570

For all general information, contact Arcadia Publishing:
Telephone 843-853-2070
Fax 843-853-0044
E-mail sales@arcadiapublishing.com
For customer service and orders:
Toll-Free 1-888-313-2665

Visit us on the Internet at www.arcadiapublishing.com

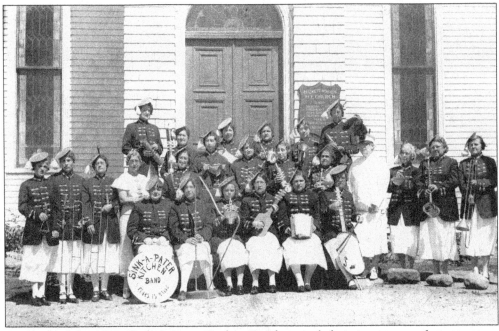

Members of the 1930s Sink-A-Pater Kitchen Band created their instruments from common kitchen implements—an example of island ingenuity and creativity. The unidentified band members are shown here posing in front of the Brackett Memorial Church on Peaks Island. (5th Maine Regiment Museum collection.)

CONTENTS

ACKNOWLEDGMENTS

Many thanks to the following, who contributed images and information for this book: the 5th Maine Regiment Museum, Pam Anderson, the Cliff Island Historical Society, Richard and Marge Erico, Earle G. Shettleworth Jr., the Maine Historic Preservation Commission, the National Archives, the Naval Historical Center, Jim Millinger, Donna Miller Damon, Martha Hamilton, the Chebeague Island Historical Society, the Yarmouth Historical Society, Gail K. Alverson, the Pioneer Families Association, Don Perry, Ron Adams, the 8th Maine Regiment Memorial Association, Emily Skillings Palfrey, Reta Pedersen Morrill, Ralph Ashmore, Linda Scribner, and John Brackett Seebach. Special thanks go to Paul "Fuzz" Legere for sharing his phenomenal scanning skills and to Joel W. Eastman for sharing his wealth of knowledge about Casco Bay during World War II.

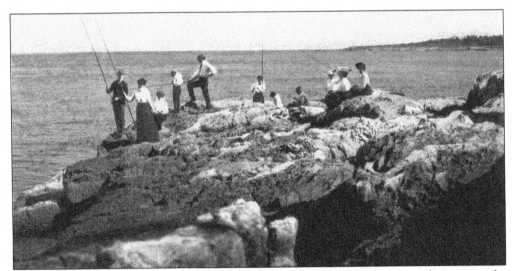

Not only is fishing a livelihood for many island families, but it is also a popular pastime for visitors. Here, a somewhat formally dressed group enjoys a leisurely afternoon of fishing at Evergreen Point on Peaks Island in the 1890s. (Author's collection.)

INTRODUCTION

Permanent settlement of the Casco Bay islands, as well as of the entire Maine coast, became possible with the conclusion of American Indian hostilities in the latter decades of the 17th century. Throughout the 18th century, coastal and island communities grew and thrived economically and socially. On the Casco Bay islands of Peaks, House, Cushing, the Diamonds, Long, Cliff, Chebeague, and Jewell, islanders drew strength and sustenance from one another through marriage and business connections.

The lives of the hardy folk who first settled the islands were shaped by the bay. Rich fishing grounds and old growth forests provided food for the islanders' families, lumber to build homes, and fuel to heat those homes. Fish were salted and dried, then shipped to mainland markets from most of the islands. Clams were dug and canned on Chebeague for sale throughout the country. A large number of vessels were built—the most famous being the stone sloops of Chebeague. These ships brought granite from the quarries "downeast" to points south for use in constructing many landmark buildings, including monuments in Washington, D.C., and New York's Cathedral of St. John the Divine.

Many descendants of the early settlers still reside on the islands. One does not have to look far to find a MacVane, a Johnson, a Trefethen, a Sterling, a Skillings, a Brackett, a Griffin, or a Woodbury. These descendants are proud of their ancestry and, with a little prompting, are happy to share the history of their family and their island with others.

People from the coastal towns around Casco Bay discovered the charms of the bay and its islands in the early 19th century. Sailing or rowing to an island on a warm summer day for picnicking or fishing became a popular pastime. At times, the harbor froze solid during the winter, and some intrepid souls would skate across or drive across in a horse-drawn sleigh to enjoy the quiet beauty of an island winter.

By the mid-19th century, islanders were ready to meet the demands of a growing number of summer visitors from all over the country. Each island responded to the challenge of catering to tourists in its own unique way. Peaks Islanders built hotels, cottages, summer theaters, and an amusement park. Cushing Island developed as a retreat for the more affluent folks. Hotels and cottages appeared on both Little and Great Diamond, and on Long, Cliff, and Chebeague Islands. At the beginning of the 20th century, dozens of steamboats brought hundreds of thousands of visitors from all over the world to the islands during the short summer season. They came to enjoy the clean fresh air and natural beauty of the bay. A trip to Casco Bay was seen as the perfect antidote to the stresses of modern urban life.

Even before 1850, the islands played an important role in the defense of Portland Harbor and Casco Bay. Military installations were built on the islands as early as 1808 to complement coastal defenses on the mainland. Over time, they were upgraded with new technology to protect the coast and bay from enemy attack. The military no longer maintains a presence on the islands, but the solid brick-and-concrete structures they left behind have become landmarks in the bay and contribute to the uniqueness of the island communities.

Fishing and lobstering continue to provide a livelihood for people on Long, Cliff, and Chebeague Islands. These occupations have all but disappeared from the other islands. Tourism remains an important industry on the Casco Bay islands, however. Islanders provide lodging and dining places for summer folk and day visitors. Island tradespeople, artists, and craftspeople depend upon the summer people for much of their income. Island organizations of every sort are supported by summer people. Many of those who commute to jobs on the mainland still earn some of their income by catering to tourists, just as islanders did a century ago.

Today's islanders are a diverse group, comprised of families who have lived on the islands for generations, and newcomers from all over the world, who seek a simpler lifestyle in a community where traditional values are cherished. Neighbors know and care about one another. Children have freedoms unknown in the city.

The only certainty about island life is that it will continue to change, just as the nation and the world continue to change. But the more things change, the more they remain the same. The Casco Bay island communities remain close-knit enclaves, ready to share their rich heritage with visitors.

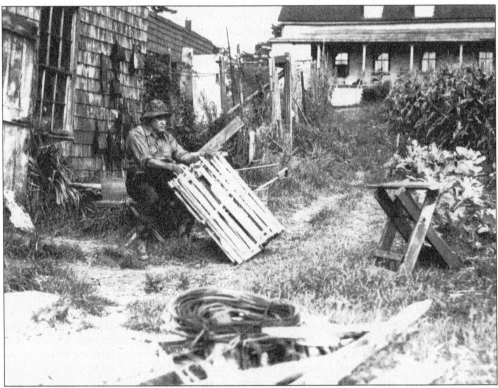

A typical island lobsterman, Capt. Al Wallace of Peaks Island, repairs a trap outside his lobster shack in this undated photograph. Like most islanders, the Wallace family grew some of their own food. Note the corn growing tall to the right. (Author's collection.)

One

Days of Peace and Prosperity

1850–1860

The islands of southern Casco Bay are inextricably bound by geography. Separated from the mainland by long stretches of water, each island has unique landscape features, which shape its personality and lifestyle. During the 1850s, most islanders engaged in maritime activities as fishermen, mariners voyaging around the globe, and boatbuilders. Fishing was supplemented by farming, small family plots being the rule. Islanders knew one another well and often intermarried, further strengthening the ties that bound them together.

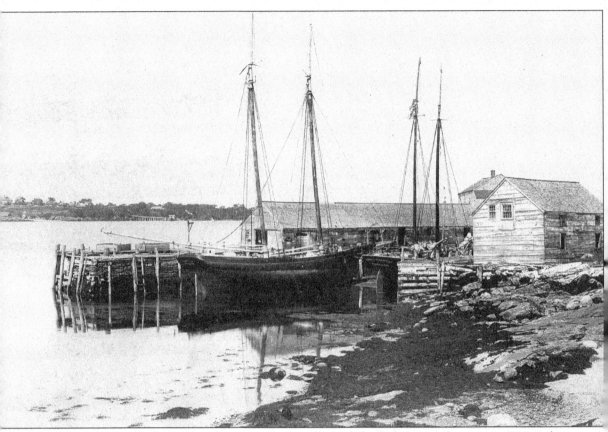

Henry Trefethen and John Sterling came to House Island from Monhegan *c.* 1784 and established separate fishing businesses. By the 1850s, the businesses were thriving and their large families began settling on nearby Peaks and Cushing Islands. In the scene above, a fishing vessel is docked at the wharf below the House Island fish houses. (Maine Historic Preservation Commission collection.)

John Sterling (1785–1870), seen to the right, and his wife, Patience Browe (1784–1853), below, shared a duplex house on House Island with Henry Trefethen (1797–1880) and his wife, Mary "Polly" Thompson (1795–1880). Patience and Polly kept the doors open to all who needed shelter. Family members tell of a Native American woman who came one evening, gave birth during the night, and then left with her newborn babe in the morning. (Maine Historic Preservation Commission collection.)

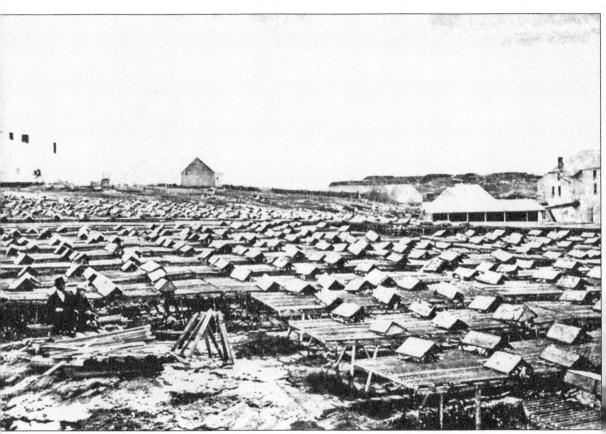

Fish were salted and dried on the fish flakes (drying racks), which covered most of House Island, before being packed in wooden barrels and sent to market. Here, Clara Sterling Turner and Thomas Cudworth are seated in front of one of the flakes. (Maine Historic Preservation Commission collection.)

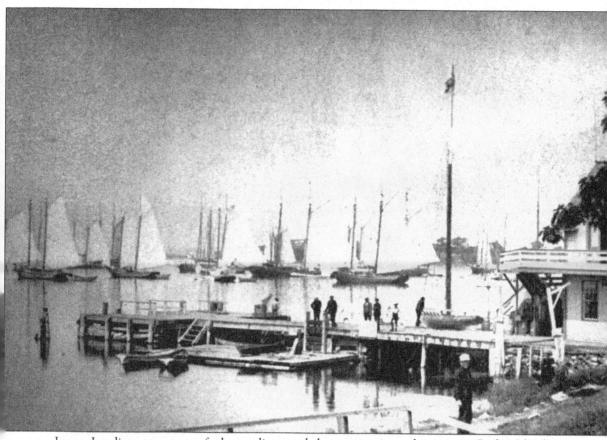

Jones Landing was one of the earliest and longest-serving wharves on Peaks Island. William T. Jones left Portsmouth, New Hampshire, to marry Almira Brackett Welch of Peaks. A cooper by training, he established a shop at the head of the wharf. The shop was the first of several island business ventures for the Jones family. (Author's collection.)

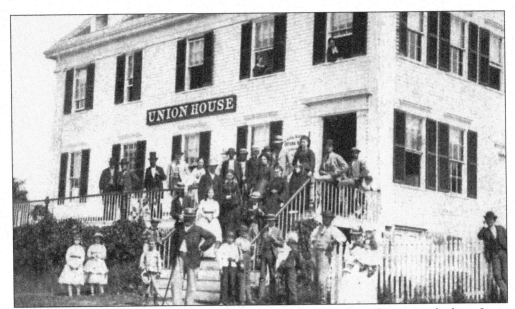

William and his second wife, Eliza Chamberlain, built their large home overlooking Jones Landing. During the 1850s, they began taking in guests, calling their home the Union House. William boasted that he was the first hotel keeper in Casco Bay, though, in reality, Eliza ran the business. (Maine Historic Preservation Commission collection.)

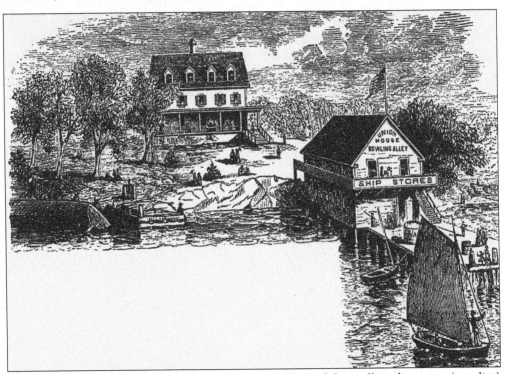

Another of the Jones family businesses was a bowling alley and shop selling ship stores (supplies) on the wharf. Bowling was a popular sport; Peaks Island had five bowling alleys, one of which was for outdoor lawn bowling. (Author's collection.)

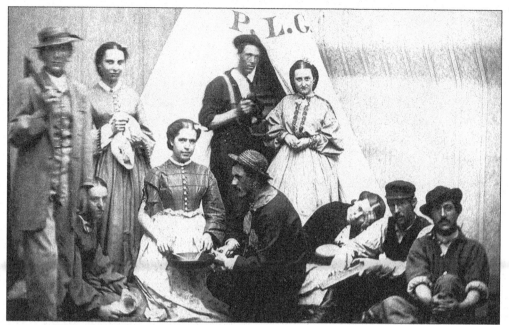

Few cottages existed on the islands in the 1850s. During the summer months, overnight visitors often camped out. Peaks Island sported two tenting areas, the Sterling campground at Evergreen Landing and the Brackett Campground at Forest City Landing. The identity of the group above, seen posing in front of a tent on one of the islands, is unknown. (Maine Historic Preservation Commission collection.)

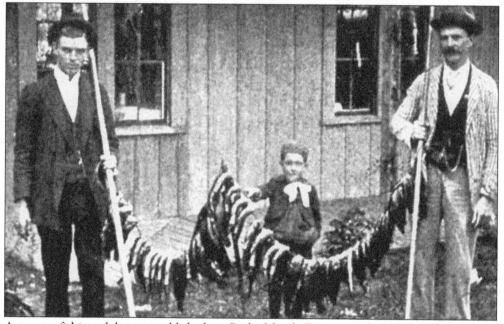

A cunner fishing club was established on Peaks Island. Cunner are brilliantly colored spiny-finned fish that were once abundant in the waters of Casco Bay. Here, the unidentified fishermen and their young assistant display the day's catch. Looks like enough for quite a fish fry. (Author's collection.)

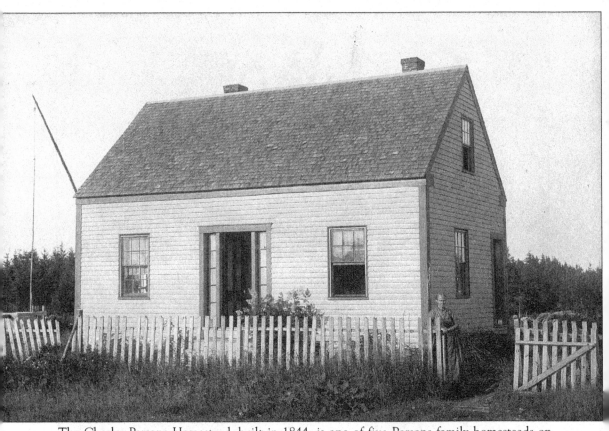

The Charles Parsons Homestead, built in 1844, is one of five Parsons family homesteads on Peaks Island. The Parsons kept a large herd of cows and provided most of the dairy products on the island well into the 20th century. The lady in the photograph may be Charles's sister, Mary Parsons Millett. (Maine Historic Preservation Commission collection.)

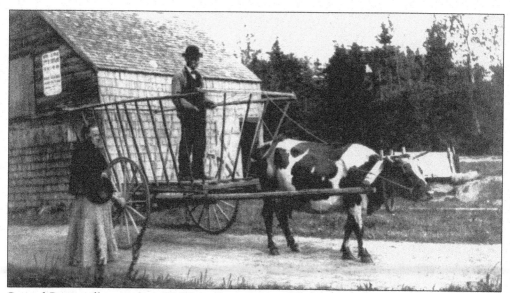

Samuel Pettengill arrived on Cliff Island c. 1813, and by the mid-1800s, the Pettengill family owned nearly half of the island. Like other island families, the Pettengills fished and farmed. Shown here are Mr. and Mrs. Pettengill. Notice that she walks while he enjoys the ride. (Cliff Island Historical Society collection.)

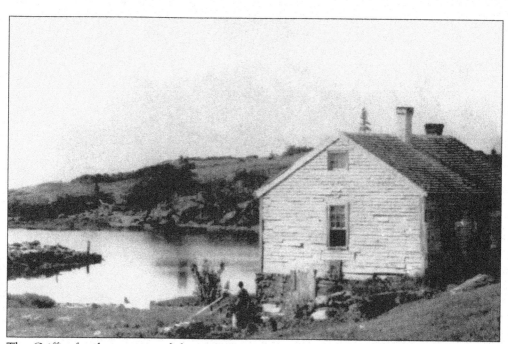

The Griffin family was one of the earliest to settle on Cliff Island. This house in Griffin's Cove was the first house built on the island. It was torn down in the 1930s. (Cliff Island Historical Society collection.)

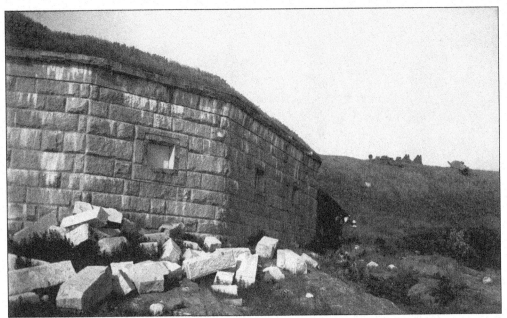

As the decade of the 1850s drew to a close and war loomed on the horizon, the federal government upgraded Fort Scammel on House Island. The brick-lined earthen fort, with its wooden blockhouses, was replaced by granite bastions. As evidenced by this photograph, the chunks of leftover granite were visible long after construction was completed. (5th Maine Regiment Museum collection.)

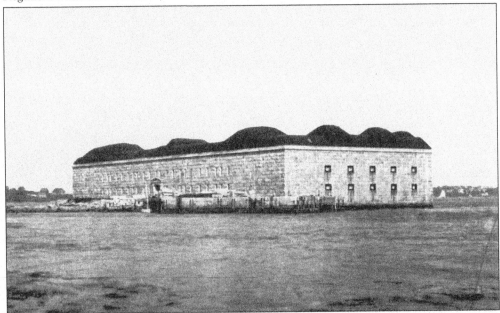

In 1858, Fort Gorges on Hog Island Ledge joined Fort Scammel and Fort Preble in South Portland as the third point of defense in Portland Harbor. Constructed of granite and equipped with Rodman guns, the fort's design and location allow it to overlook the main shipping channel into Portland Harbor, as well as the western passage between the Diamond Islands and the mainland. (Author's collection.)

Two

THE CIVIL WAR
1861–1865

Even before Fort Sumter was fired upon in April 1861, islanders were involved in the movement to abolish slavery. Some joined antislavery societies; others promoted abolition via the printed word. Although not yet proven, a few island homes are rumored to have been stops on the Underground Railroad. Island men served in the army and navy. One, Wesley Scott of Peaks Island, died in a Confederate prison camp in Salisbury, North Carolina. The war came to Casco Bay in June 1863, when a contingent of the Confederate navy invaded Portland Harbor, intending to burn the city of Portland, just as the British had done in 1775.

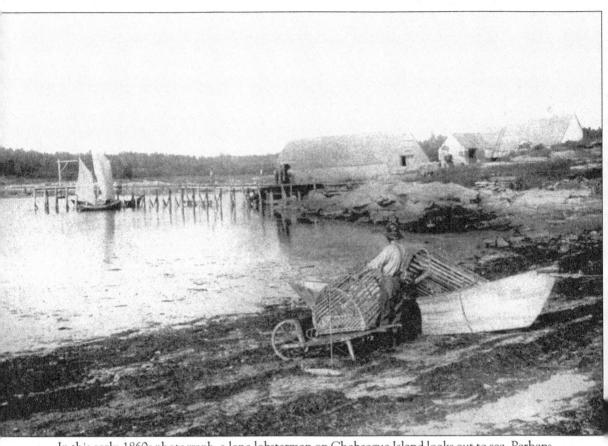

In this early-1860s photograph, a lone lobsterman on Chebeague Island looks out to sea. Perhaps he is contemplating the coming turmoil of war. (Author's collection.)

Before and during the Civil War, some islanders were involved in activities supporting abolition. Robert F. Skillings wrote and published poetry to express his opposition to both slavery and "demon rum." Skillings was born on Cushing Island but moved to Peaks Island after his marriage to Harriet Trefethen. (5th Maine Regiment Museum collection.)

PROHIBITION AMENDMENT.

NOTICE EXTRA—SEPTEMBER 8, 1884.

VOTE YES.

Let every man who loves his home
 And wishes God to bless,
To-day unto this ward room come
 And by his vote say yes.

If any one has any doubt
 Or feels disposed to guess,
For Jesus' sake, just cast it out
 And for His sake, vote yes.

To-day, my friend, you have the power
 To help relieve distress.
Come to the box this very hour
 And let your vote say yes.

Skillings wrote this poem to encourage islanders to vote in favor of the proposed amendment to prohibit the sale of alcoholic beverages in Maine. (5th Maine Regiment Museum collection.)

Charlotte J. Thomas, a member of one of Peaks Island's founding families, the Bracketts, was one of Portland's most outspoken abolitionists. She often hosted other well-known abolitionists, including Frederick Douglass and Ellen Crafts, at her mainland home or her summer residence, the Valley View House on Peaks Island. (Author's collection.)

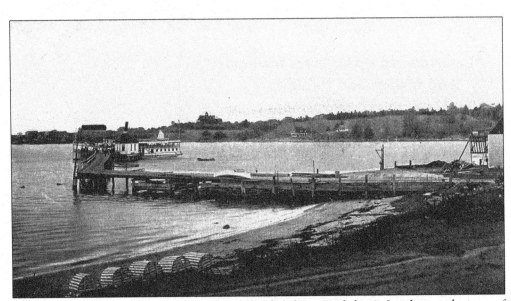

Guests at the Valley View House enjoyed the beach at Trefethen's Landing and views of Diamond Passage between Peaks and the Diamond Islands. Captain Trefethen's fish house is seen at the extreme right of this image. (Author's collection.)

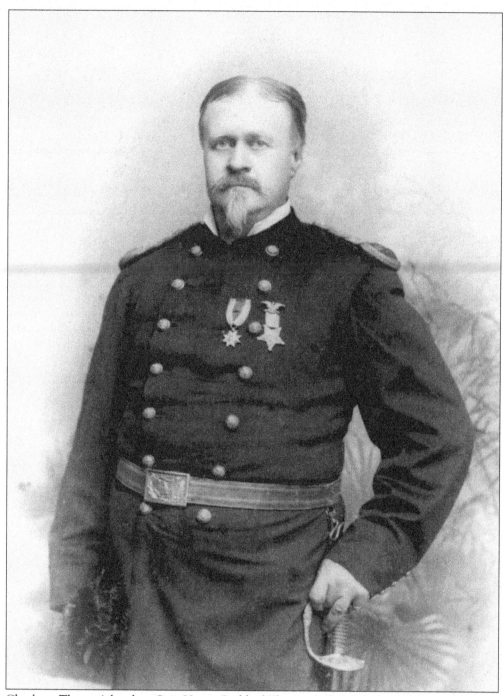

Charlotte Thomas's brother, Gen. Henry Goddard Thomas, enlisted in the 5th Regiment Maine Volunteer Infantry in 1861. He was later chosen to recruit, train, and command two of the first "colored regiments" mustered into the regular army during the Civil War. General Thomas found his calling in the army, serving for 40 years. Another brother, Daniel, acted as a conductor on the Underground Railroad in Portland, helping to assist runaway slaves to freedom in Canada. (5th Maine Regiment Museum collection.)

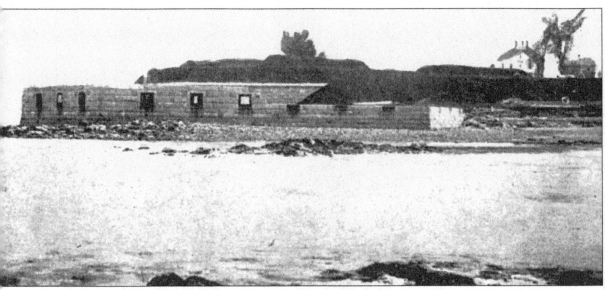

Forts Gorges, Scammel, and Preble (seen here) guarded the entrance to Portland Harbor in the 1860s. Each was constructed of granite and topped with several feet of earth to withstand bombardment from enemy attack. Today, Fort Gorges sits empty, Scammel is privately owned, and Preble is home to the campus of Southern Maine Technical College. (Author's collection.)

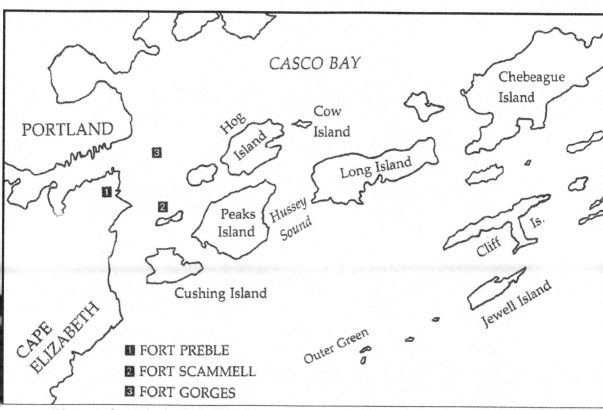

CASCO BAY

PORTLAND

Chebeague Island

Hog Island

Cow Island

Long Island

Peaks Island

Hussey Sound

Cliff Is.

Cushing Island

Jewell Island

CAPE ELIZABETH

Outer Green

■ FORT PREBLE
■ FORT SCAMMELL
■ FORT GORGES

This map shows the location of Forts Gorges, Preble, and Scammel. In 1861, South Portland had not yet separated from Cape Elizabeth, and the Diamond Islands were known by their original European names of Little and Great Hog Islands. These forts are now landmarks in the bay. (Author's collection.)

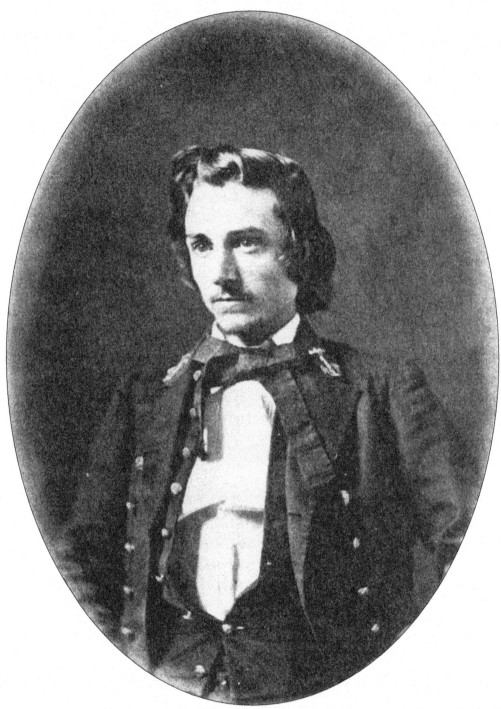

In June 1863, Lt. Charles W. Read of the Confederate navy and his crew snuck into Portland Harbor and stole the revenue cutter *Caleb Cushing*. Under cover of darkness, they managed to sail her out of the harbor through the passage between Peaks and Hog Islands into Hussey Sound and on toward Jewell Island, where the ship became becalmed (made motionless by a lack of wind). (Naval Historical Center collection.)

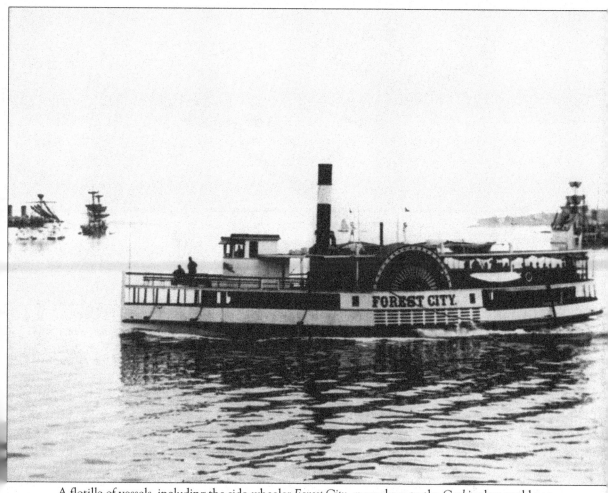

A flotilla of vessels, including the side-wheeler *Forest City*, gave chase to the *Cushing* but could not get close enough to retake her, since they were unarmed and could not return fire to the *Cushing's* guns. As she was steaming into the harbor from a trip to Boston, the *Forest City* had passed the *Cushing* leaving the harbor and reported her departure to the authorities. (Author's collection.)

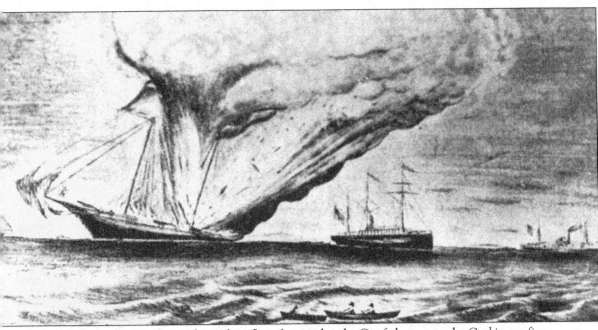

Before abandoning ship under a white flag of surrender, the Confederates set the *Cushing* on fire. They were captured and briefly imprisoned at Fort Preble before being taken to Fort Warren in Boston Harbor. This sketch by Portland artist Harrison B. Brown depicts the burning of the *Cushing*. (5th Maine Regiment Museum collection.)

Three

DOWN THE BAY
1870–1920

The years following the Civil War brought a new type of people to the islands—summer visitors from around the world. Portland became a stop for both intrastate and interstate steamboat lines, and rail lines from the north, south, and west terminated in the city. Numerous steamers provided easy access to many of the islands throughout Casco Bay. Each island responded to the demands of visitors in its own way. On the "down the bay" islands of the Diamonds, Long, Cliff, and Chebeague, hotels and cottages were built, and restaurants, shops, and entertainment were provided. Cushing, too, sported a hotel and large cottages for more affluent folks looking for a quiet retreat.

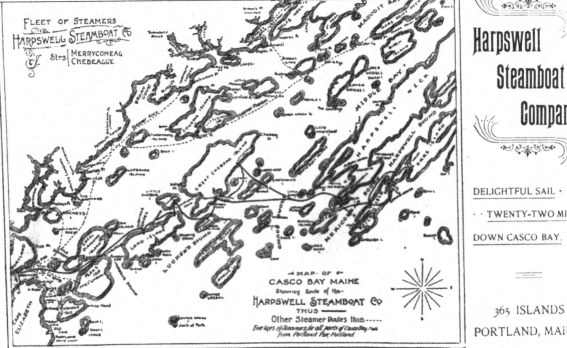

During the 1850s and 1860s, several attempts were made to establish ferry service in Casco Bay. In 1872, the first permanent, year-round service to Peaks Island began. By 1900, at least a dozen steamboat lines were ferrying passengers throughout the bay during the summer season. The image above shows the routes of the Harpswell Steamboat Company. (Author's collection.)

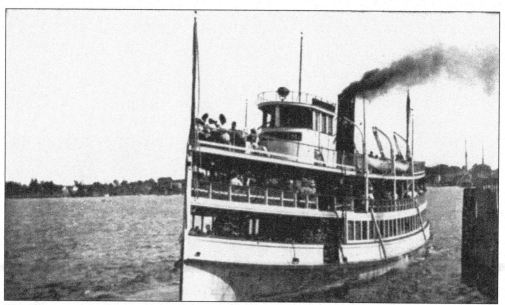

The *Pilgrim* was the largest steamboat in the fleet. Her three decks carried nearly 1,000 passengers to Peaks Island several times a day. Occasionally, she made Sunday afternoon trips to Old Orchard Beach. (Author's collection.)

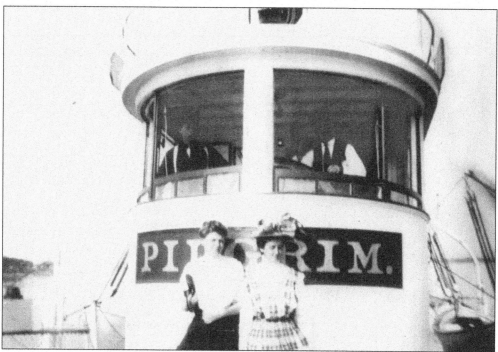

Here, two young women enjoy the salt air aboard the *Pilgrim c*. 1900. Behind them, the steamer's captain and crew member look out from the wheelhouse. (Author's collection.)

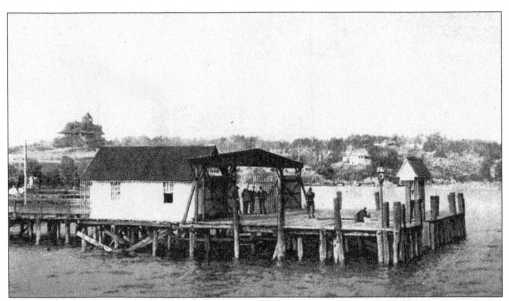

Most of the islands in the bay had a steamboat landing; some had several. The shed pictured here on Great Diamond Island sheltered freight and passengers from inclement weather. The large building in the background is the summer home of the Portland Club. (Author's collection.)

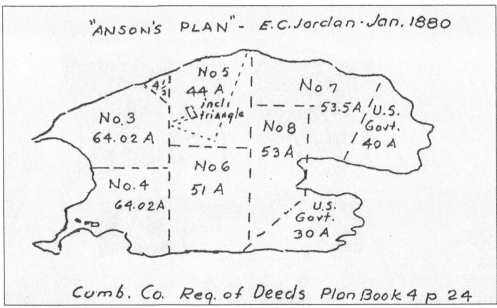

Reliable transportation to the islands was followed by land speculators and developers seeking business opportunities. "Anson's Plan" shows the division of land on Great Diamond Island in 1890. (Cumberland County Registry of Deeds collection.)

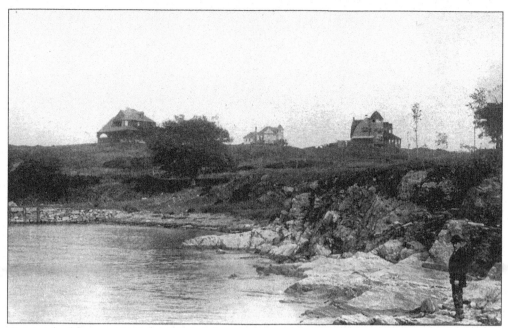

Cottage building on the islands began in earnest in the 1880s and continued throughout the first two decades of the 20th century. As on other islands, the trees on Great Diamond had been harvested and sheep pastured there. Shown here are a few of the early cottages on the island. (Author's collection.)

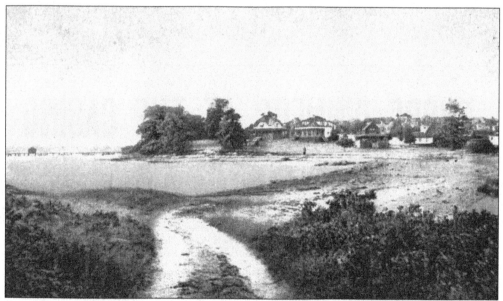

A sandbar connects Little and Great Diamond Islands. At low tide, it is solid enough to accommodate both foot and vehicular traffic. At high tide, it is several feet under water. (Author's collection.)

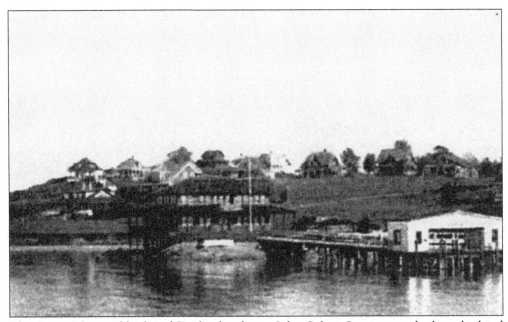

The Casino, designed by famed Portland architect John Calvin Stevens, was built at the head of the landing on Little Diamond Island *c.* 1908 as a sort of resort. It offered patrons the chance to catch their meal from the Casino Aquarium, swim in the heated saltwater pool, and lodge in the Casino's guest quarters. (Author's collection.)

SHORE DINNERS AT THE CASINO
LITTLE DIAMOND ISLAND
Now Open for Inspection of the Public

MEALS AT ALL HOURS, 6.30 A. M. TO 10.30 P. M.

Live Fish and Lobsters immediately out of the water from **The Casino Aquarium,** caught and cooked while you wait, Salt Water Fish, but warranted absolutely fresh (fishing allowed 10c to 50c a haul)

An entirely new departure for Portland **A faultless Bill of Fare and Unsurpassed Table Service** The European Plan has been adopted

A limited number of rooms will be furnished to people wishing for both meals and lodging. Seating capacity at tables 150, and this can be increased to 250 when conditions demand it.

George W. Brown, who managed the Casino during the first decade of the 20th century, advertised in the local newspapers, inviting people to visit the Casino. (Author's collection.)

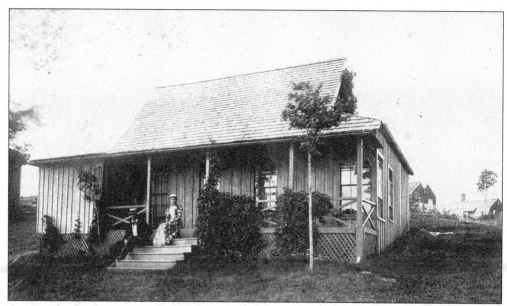

A typical island cottage, the Hall cottage on Little Diamond features board-and-batten siding, a front porch, and, of course, vines growing up the front of the cottage. The unidentified couple sitting on the steps may be members of the Hall family. (Maine Historic Preservation Commission collection.)

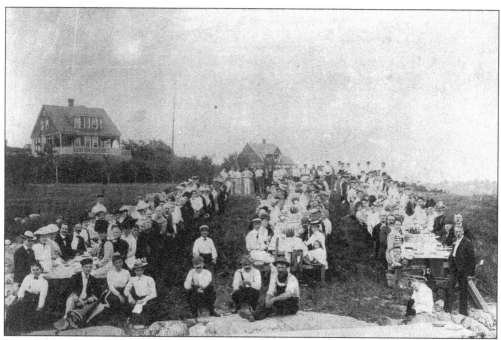

Little Diamond Island became well known for its Sunday clambakes. These guests look as though they are eagerly awaiting the feast. (Maine Historic Preservation Commission collection.)

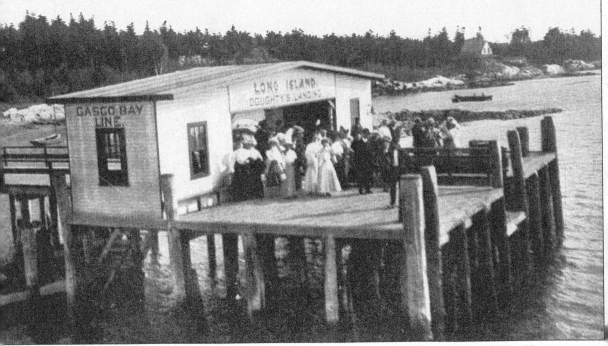

Long Island, too, was discovered by summer visitors in the years following the Civil War. Here, a group waits for the boat on Doughty's Landing, one of several steamboat landings on the island. Are they waiting for friends and family to arrive, or are they heading home after a day of fun and food on the island? (Maine Historic Preservation Commission collection.)

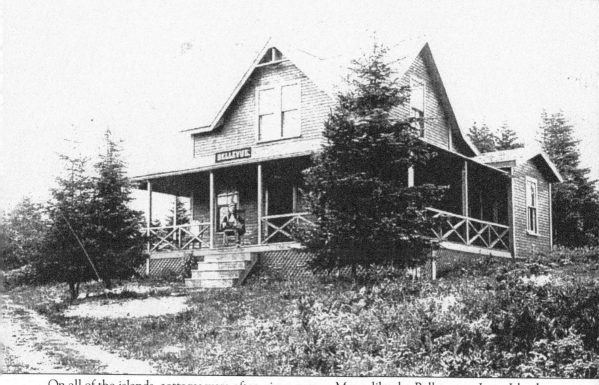

On all of the islands, cottages were often given names. Many, like the Bellevue on Long Island, reflected what the owners thought of their surroundings. The man seen here on the porch seems to be enjoying the beautiful view. (Maine Historic Preservation Commission collection.)

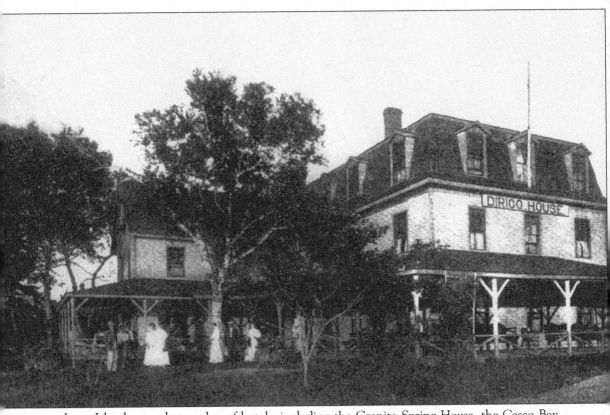

Long Island sported a number of hotels, including the Granite Spring House, the Casco Bay House, the Beach Avenue House, and the Dirigo House (pictured here). Guests would often stay for the entire summer season, enjoying weekly clambakes and sailing parties. (5th Maine Regiment Museum collection.)

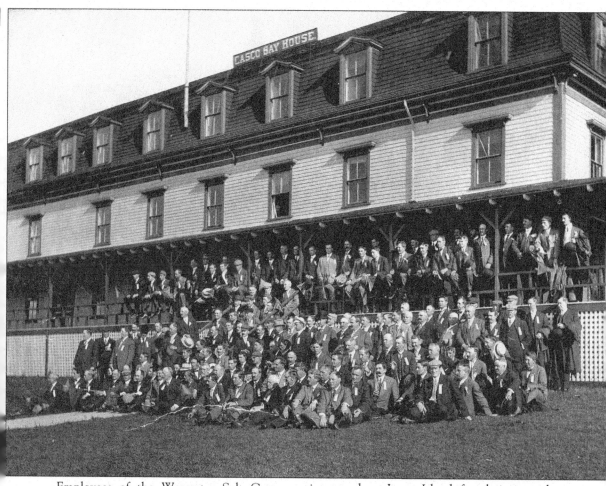

Employees of the Worcester Salt Company journeyed to Long Island for their annual company outing on September 11 and 12, 1909. They are posed here in front of the Casco Bay House for the company photograph commemorating their excursion. (Maine Historic Preservation Commission collection.)

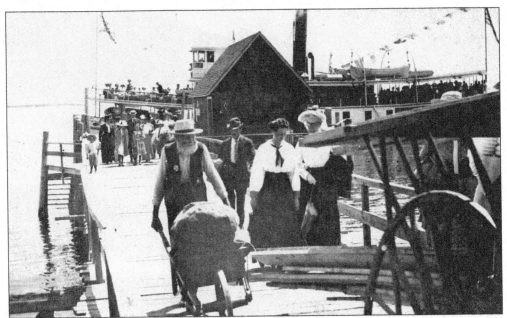

"Meeting the boat" means greeting returning neighbors and friends and receiving mail and all kinds of goods. In summertime, islanders meet the boat to observe the ever-present tourists. Here, folks are debarking c. 1900 at Central Landing on Great Chebeague Island after a day of shopping on the mainland. (Author's collection.)

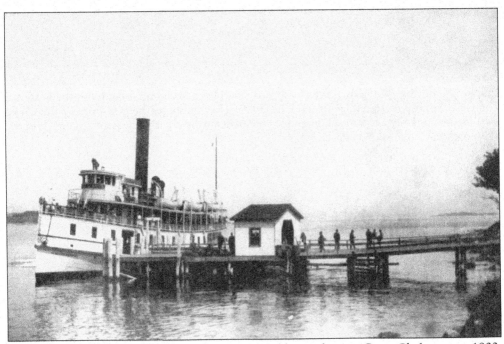

Here, the steamer *Machegonne* is docked at Littlefield's Landing on Great Chebeague c. 1900. Chebeague, the largest island in Casco Bay, is known as the "island of many springs" because of the many freshwater springs and ponds on the island. (Donna Miller Damon collection.)

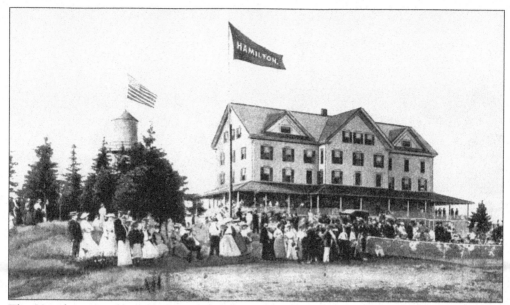

The Hamilton Hotel on Chebeague held a field day in 1911. Note the tennis net stretched across the field; tennis was becoming a popular sport during the early 20th century. (Donna Miller Damon collection.)

Here, a large crowd is gathered on the lawns of the Hillcrest Hotel (left) and the Summit House on field day to watch a man being rolled in a barrel. (Donna Miller Damon collection.)

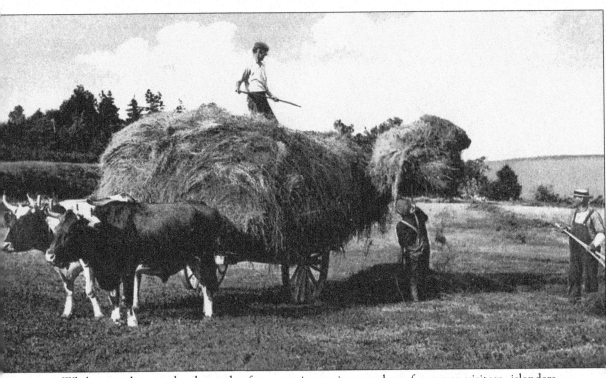

While attending to the demands of an ever-increasing number of summer visitors, islanders continued to pursue their traditional occupations. Uncle John's ox team pulled this load of freshly cut hay to the barn for winter storage on one of the island's many saltwater farms. (Donna Miller Damon collection.)

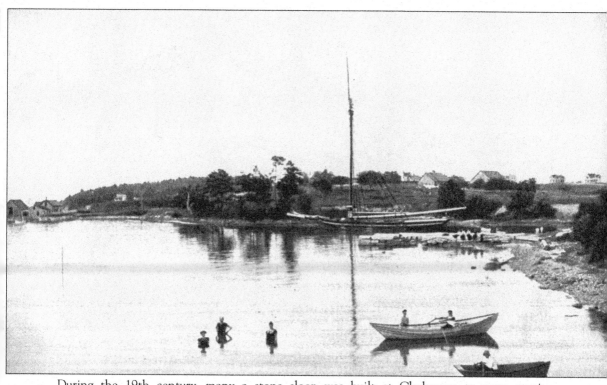

During the 19th century, many a stone sloop was built at Chebeague to carry granite to southern cities. Pictured here is the *Lettie Hamilton*, anchored in Cleaves Cove. (Donna Miller Damon collection.)

Cliff Island also welcomed its share of summer visitors, who stayed in small hotels like the Auccocisco House (pictured here) or in numerous cottages built during this era. The visitors came to enjoy the ocean breezes and quiet of the island. (Cliff Island Historical Society collection.)

Here, youngsters model the latest fashions on Cliff Island c. 1900. The mustached fellow with the bowler joined in the "fashion parade." (Cliff Island Historical Society collection.)

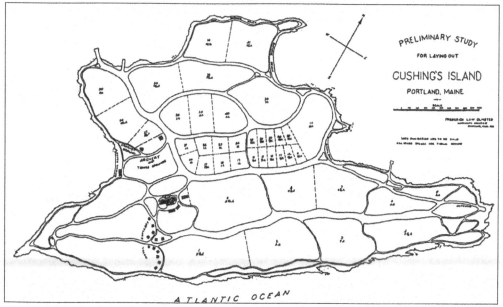

Many of the islands in Casco Bay blossomed as summertime haunts of the working and middle classes. In contrast, the owners of Cushing Island developed the island as a retreat for the more affluent classes. Famed landscape architect Frederick Law Olmsted was engaged to develop a landscape plan in 1883. (Author's collection.)

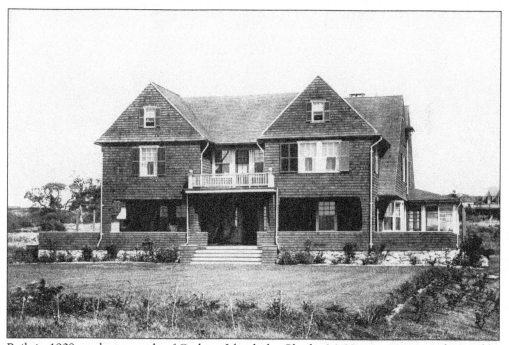

Built in 1909 on the west side of Cushing Island, the Charles M. Hayes cottage was designed by noted Portland architect John Calvin Stevens in partnership with his son, John Howard Stevens. It combines elements of the Shingle, Colonial Revival, and Arts and Crafts styles. Hayes was a resident of Montreal and president of the Grand Trunk Railway. (Author's collection.)

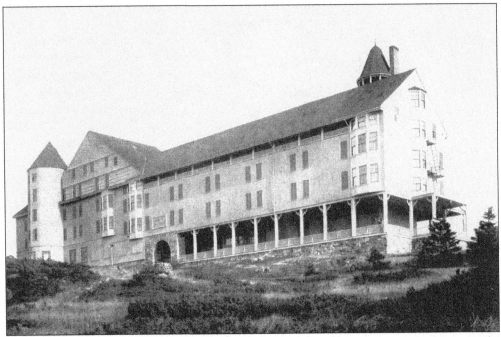

Designed by Portland architect Francis Fassett, the second Ottawa House was built in 1888 by Lemuel Cushing of Montreal, Canada, to replace the first Ottawa House, which had burned previously. The second Ottawa House burned in 1917. (Author's collection.)

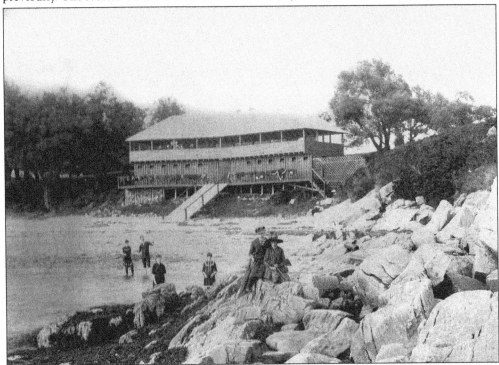

Guests at the Ottawa House could change into their bathing costumes in a bathhouse located on the beach below the hotel. (Maine Historic Preservation Commission collection.)

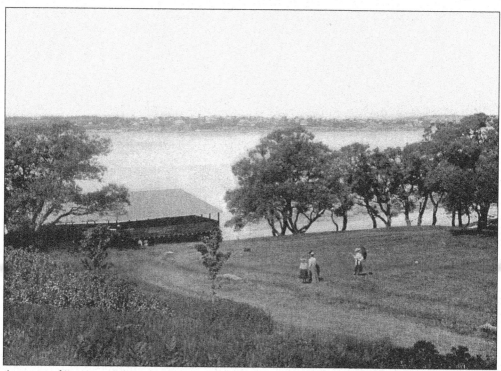

A group of "rusticators" enjoys the view of Portland Harbor from the western end of Cushing Island c. 1900. The city of Portland is in the distance.

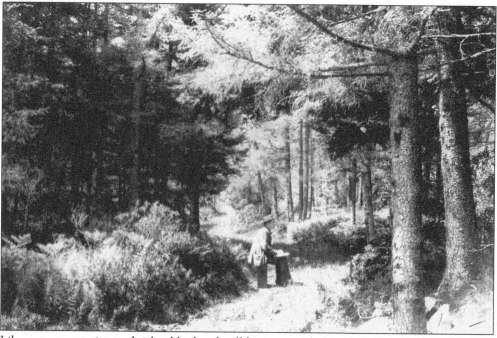

Like any community, each island had and still has an area known as lovers' lane. Here, we see a young man at the lovers' lane on Cushing Island. Perhaps he is writing a poem or letter to his special girl. (Maine Historic Preservation Commission collection.)

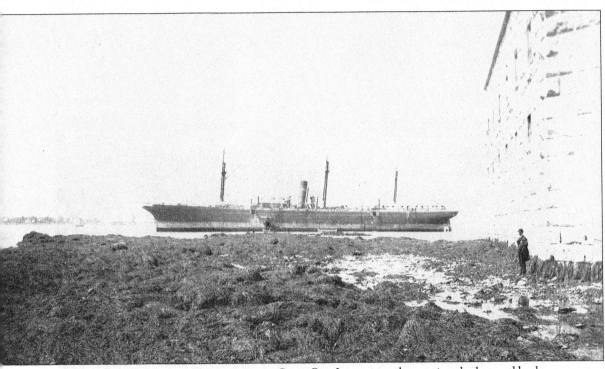

Shipwrecks were a common occurrence in Casco Bay. Larger vessels entering the bay and harbor sometimes resulted in ships running aground on underwater reefs. The steamer *Brooklyn* ran aground on Hog Island Ledge in 1883. Fort Gorges (on the right) is built on the ledge. (Maine Historic Preservation Commission collection.)

Four

ISLE OF ARCADY
1870–1920

Catering to summer visitors on Peaks Island became, in many ways, a large extended family enterprise. By the 1870s, the families that had settled the island were very much interrelated by blood or marriage. They built and operated campgrounds, hotels, cottages, restaurants, shops, and a wide variety of entertainment facilities. They also leased or sold land to others to do the same. Under their direction, Peaks developed into one of the most popular summer resorts in the United States. The press often referred to the island as "the Coney Island of Maine," due to its similarity to Coney Island, New York. Each "Coney Island" sported bustling commercial districts where a wide variety of food, lodging, and the latest "amusements" could be found. Each island also featured separate residential areas for those seeking quiet family-centered vacations.

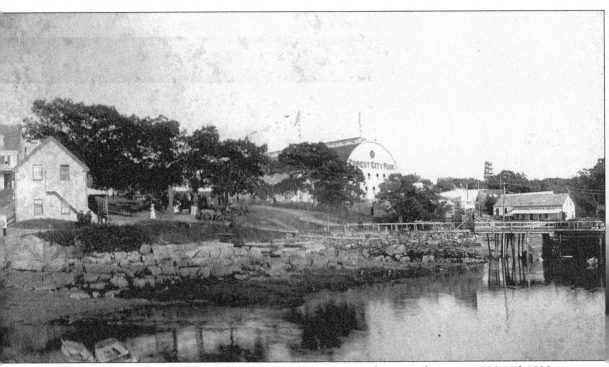

Many of the Casco Bay islands benefited from the increased tourism between 1880 and 1920, but Peaks Island received the largest share due, in no small way, to the entrepreneurial skills of its year-round residents. Dozens of steamboats brought hundreds of thousands of visitors to the many steamboat landings during the short summer season. Visitors could roller-skate at the Forest City Rink or enjoy a meal at the Mineral Spring House. (Maine Historic Preservation Commission collection.)

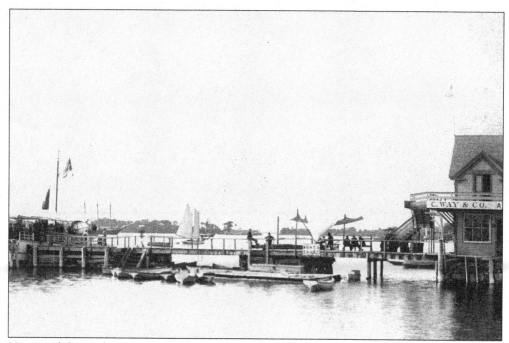

Visitors did not have far to go to purchase medicines. The C. Way & Company shop was located right on Jones Landing, adjacent to Forest City Landing. (Maine Historic Preservation Commission collection.)

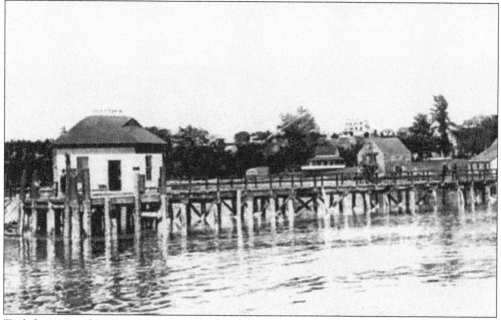

Trefethen's Landing, pictured *c.* 1900, was one of several steamboat-ferry landings on Peaks Island. Captain Trefethen's fish houses sit at the head of the landing. The three-story building in the background is the Oceanic House on Beacon Hill, a hotel under the proprietorship of Robert Thayer Sterling. It burned in a spectacular fire in 1949. The landing was destroyed by hurricanes in the 1960s. (Author's collection.)

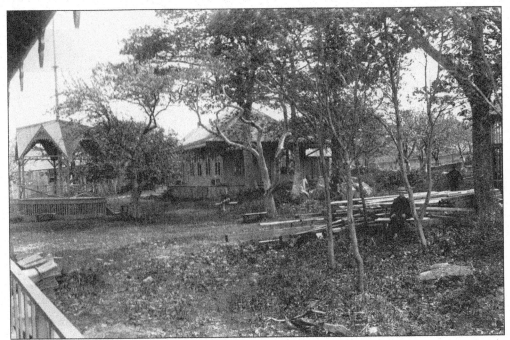

Greenwood Garden opened as a picnic grove in the 1850s. By the 1880s, the Brackett family began to transform the garden into what would become an amusement park. This *c.* 1875 view shows piles of lumber and packets of shingles for the buildings under construction. (Maine Historic Preservation Commission collection.)

The Peaks Island Rink was built in Greenwood Garden *c.* 1880 for open-air roller-skating. In the 1890s, it was converted for use as a summer theater, the Greenwood Garden Playhouse. Today, the playhouse still hosts variety shows, concerts, an occasional play, and the like. (Maine Historic Preservation Commission collection.)

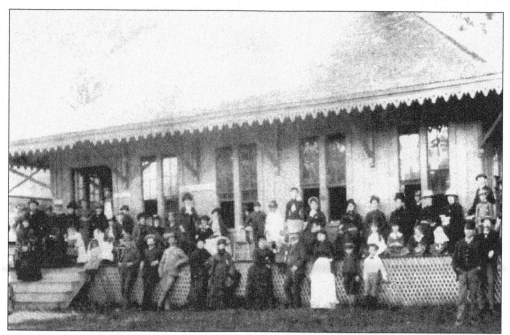

Here we see a group of patrons outside the Greenwood Garden BeerHaus *c.* 1885. The establishment served root beer, ginger beer, and sassafras beer. Although Maine was a dry state, the Greenwood Garden BeerHaus was rumored to have sold alcoholic beer. (5th Maine Regiment Museum collection.)

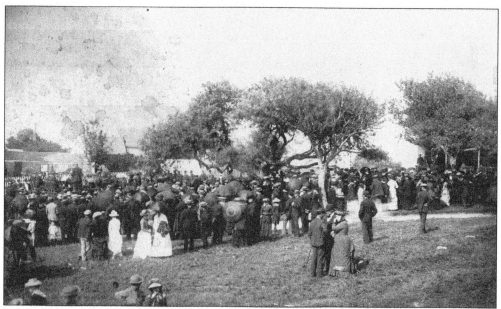

Here, a large crowd gathers in Greenwood Garden *c.* 1900. Was it a holiday or just a normal vacation day on the island? (Maine Historic Preservation Commission collection.)

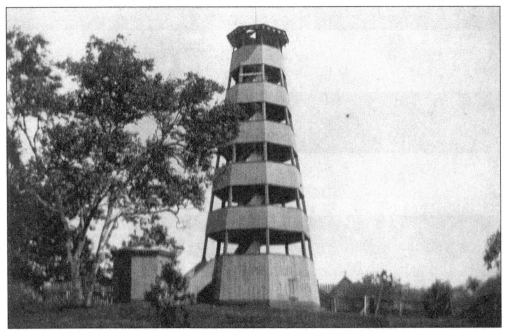

Greenwood Garden contained many kinds of entertainment, including a carousel, a Ferris wheel, a midway, live animal displays, and this wooden observatory. Patrons would pay for the privilege of climbing to the top to catch a glimpse of Mount Washington in New Hampshire. (Maine Historic Preservation Commission collection.)

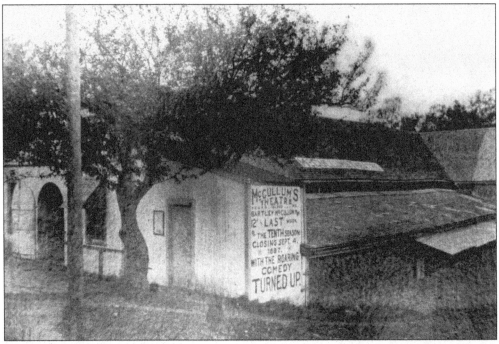

The Pavilion Theatre opened in 1887. It is said to have been the first summer theater in the United States. It burned in a spectacular 1921 fire that engulfed a dozen buildings. (5th Maine Regiment Museum collection.)

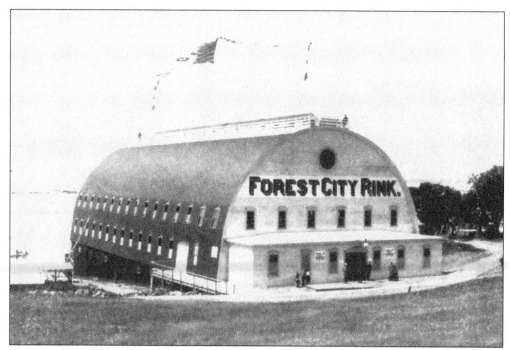

In 1898, the Forest City Rink was converted to a summer stock theater and renamed the Gem. It would become the most famous of Peaks Island's theaters. The interior of the theater was quite luxurious, with upholstered seats and electric lights. Note the anchor hanging above the balcony. (Maine Historic Preservation Commission collection.)

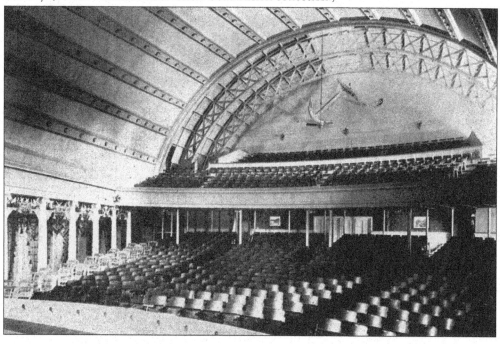

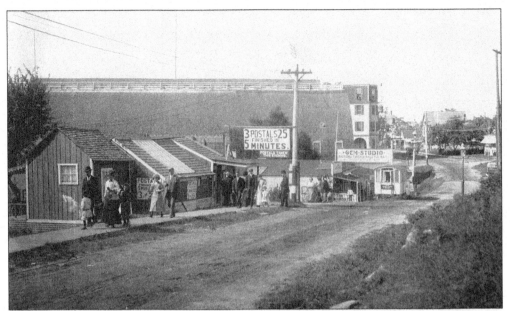

Adjacent to the Gem were two photo shops where patrons could have their photograph taken and printed on postcards to send home to family and friends, for the sum of 25¢ for three cards. Here, visitors are walking on the wooden boardwalk that ran from Greenwood Garden to Trefethen's Landing, a distance of about one and a half miles. (Maine Historic Preservation Commission collection.)

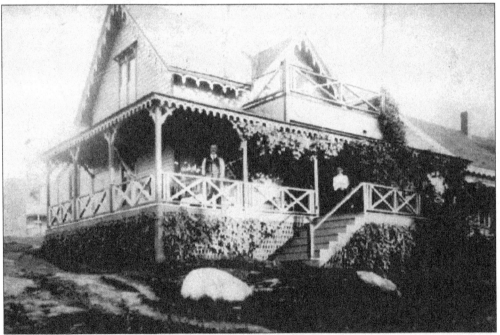

A typical island cottage, Utowna Cottage was built c. 1875 by the Trefethen family. The ell to the right was a later addition. Notice the lovely gingerbread trim and the vines growing up the sides of the cottage, popular design elements of that time period. Utowna looks the same today, minus the vines. (Author's collection.)

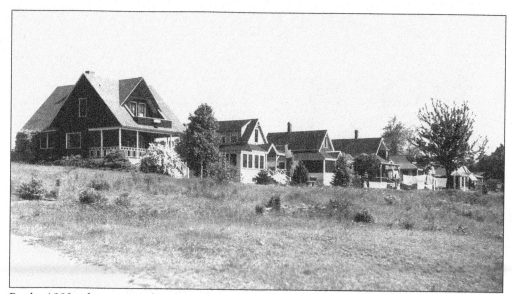

By the 1880s, the tents in the campgrounds began to be replaced with small cottages like these on Adams Street. Most measure 14 by 21 feet, with a porch added on two or three sides and trimmed with gingerbread. The style is commonly called Carpenter Gothic. (Maine Historic Preservation Commission collection.)

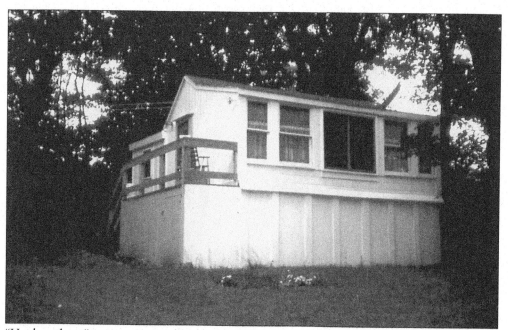

"Hook and eye" cottages were also popular. The wall and roof sections of these cottages were joined together with hook and eye fasteners, making them easy to take down and store for the winter. The cottage pictured here is on Oak Avenue. (Author's collection.)

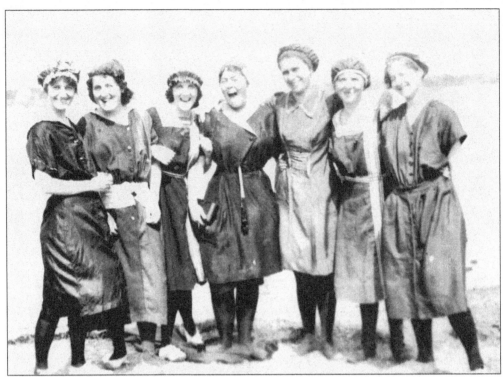

As acceptable dress codes began to loosen, a growing number of people enjoyed a bracing swim in the bay's cold waters. These bathing beauties celebrated their commencement from Vassar College in 1913 at the Pease family cottage, the Beacon, on Church Hill. Marion Pease Hudson is fifth from the left. (Author's collection.)

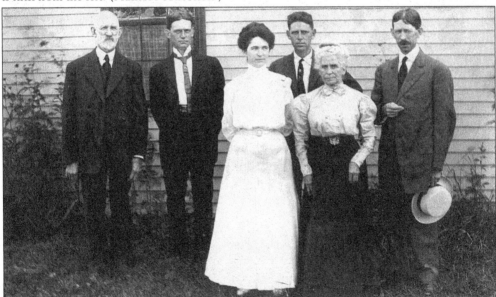

In spite of the trend toward slightly more informal attire, these unidentified folks appear none too happy as they pose for what is probably a family photograph. (Maine Historic Preservation Commission collection.)

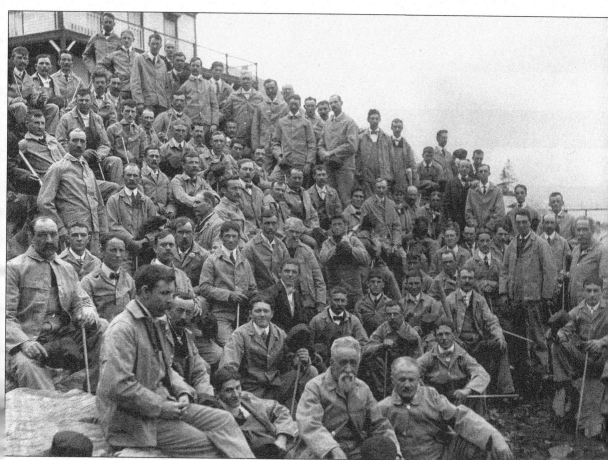

Peaks Island hosted many a company outing. Here, members of the Bricklayers and Masons Union pose for a company photograph at their annual outing. (Maine Historic Preservation Commission collection.)

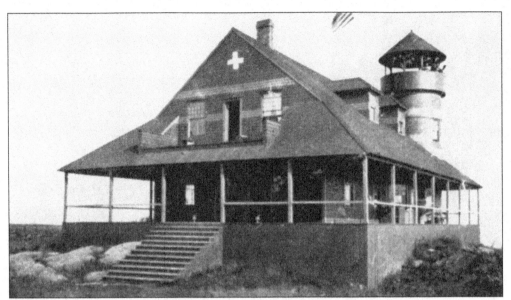

Communal living came to Peaks Island in 1888, when the veterans of the 5th Regiment Maine Volunteer Infantry built their reunion hall on the south shore of the island. The veterans and their families vacationed in the hall, sharing the 15 bedrooms, the kitchen, and the dining room. The regiment had participated in some of the heaviest fighting during its three-year service in the Civil War. The hall has been restored by volunteers and is now a museum of Civil War and Peaks Island history. (5th Maine Regiment Museum collection.)

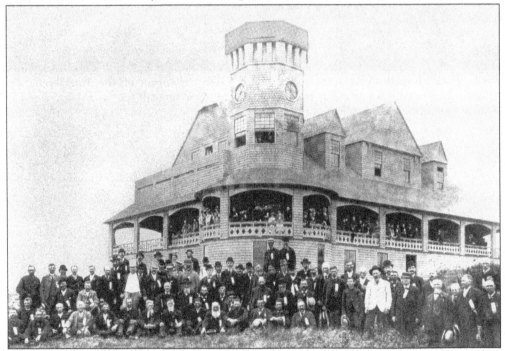

The 8th Regiment Maine Volunteer Infantry served in South Carolina and Georgia during the Civil War. In 1891, the regiment's veterans built their reunion hall on Peaks. The men and their families posed for this photograph c. 1900. (5th Maine Regiment Museum collection.)

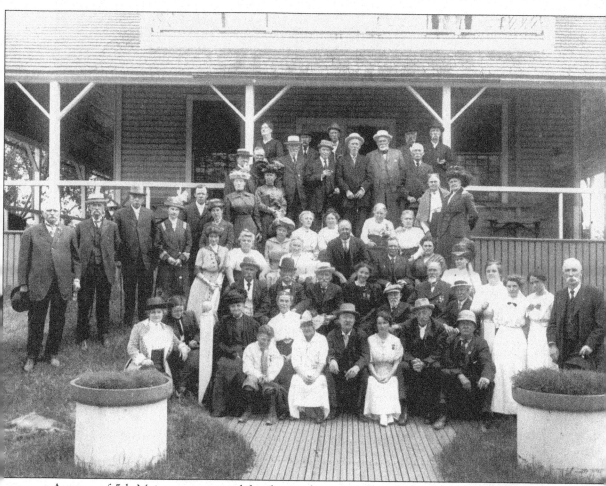

A group of 5th Maine veterans and family members poses here for a reunion photograph on the steps of the hall in 1912. The man standing at the right in front is Joshua L. Chamberlain, Maine's best-known Civil War hero. (5th Maine Regiment Museum collection.)

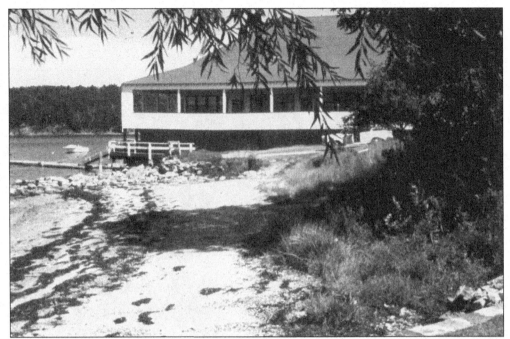

The Trefethen's Landing section of the island saw little commercial development, though numerous cottages and a few hotels were built in the area. The Dayburn Casino, adjacent to the landing, was built in 1911. Patrons would arrive by steamboat to enjoy a shore dinner followed by dancing and would then board the boat for the return trip home. (Author's collection.)

Ice harvesting proved to be a lucrative business for some islanders. Large blocks of ice packed in straw or sawdust were stored in icehouses, such as this one at Perley Knight's pond on Tolman Road, before being shipped to southern ports in the warmer months. (Author's collection.)

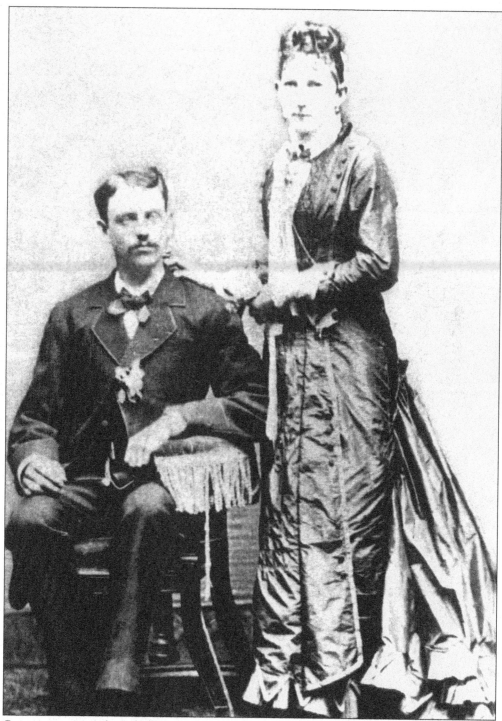

Catering to visitors brought changes to the traditional island lifestyle, which was focused on the sea, yet islanders still found time to spend with family and friends. Island weddings were major social events, attended by everyone. Donald Brackett and Emma Brightman married in 1875 in the Brackett Memorial Church. (5th Maine Regiment Museum collection.)

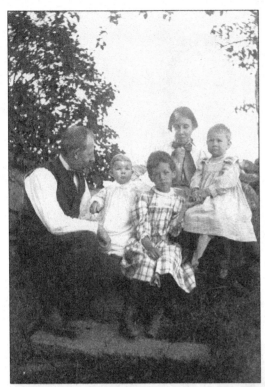

Here, Col. Henry R. Millett, a veteran of the 5th Maine Regiment, and his wife relax with their grandchildren. (5th Maine Regiment Museum collection.)

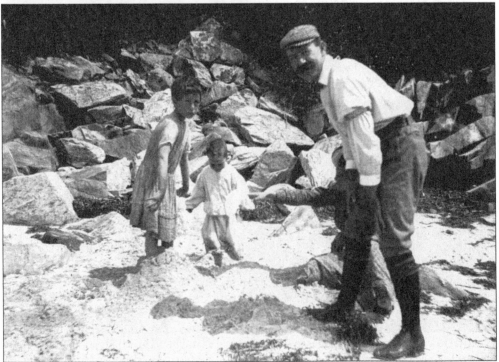

In this photograph, the Milletts' son Nathaniel plays with his children on the beach. (5th Maine Regiment Museum collection.)

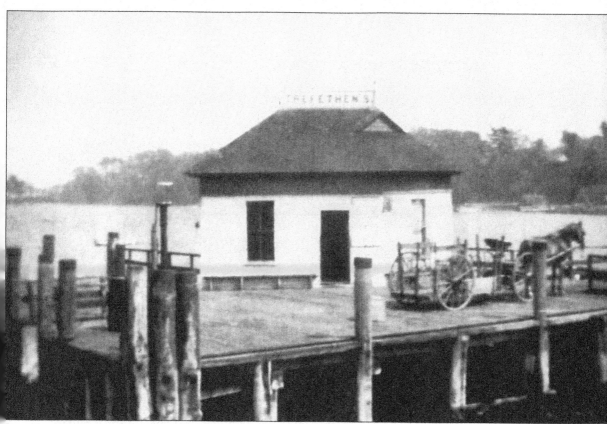

The horse-drawn buggy remained the primary means of on-island transportation. Here, an unidentified man waits for the ferry to arrive with passengers and freight at Trefethen's Landing c. 1910. (Author's collection.)

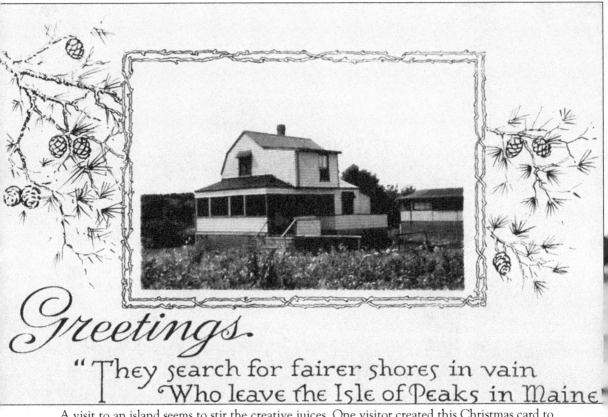

Greetings.
"They search for fairer shores in vain
Who leave the Isle of Peaks in Maine

A visit to an island seems to stir the creative juices. One visitor created this Christmas card to express her feelings about Peaks Island. (Author's collection.)

Five

DECLINE AND DEPRESSION
1921–1940

By the 1920s, the popularity of the islands began to decline. The affordability of personal automobiles made travel to areas inaccessible by public transportation much easier. The stock market crash of 1929 caused many families to lose their summer homes. Fires, both large and small, had taken their toll on the islands. There was little money and less demand to rebuild. Though tourism did continue, it was on a much smaller basis. The year-round population increased, and most residents commuted to Portland for work and school.

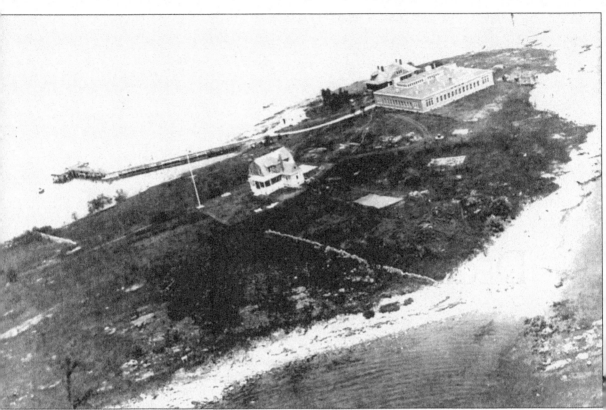

The legacy of the great immigration into the United States, and especially Portland, at the end of the 19th century was most obvious on House Island. On land acquired from the Sterling and Trefethen heirs, the government built a detention hall, hospital, and doctor's home. Passengers and crew were required to be examined for illness before going ashore. Anyone found to be ill was detained on the island. For many years, the rectangular building in this photograph was called "the quarantine hospital" by local folks. (Author's collection.)

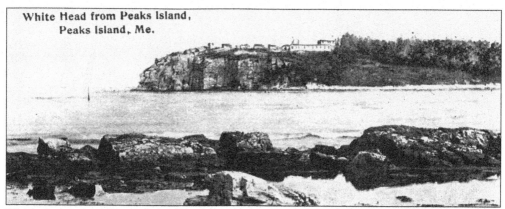

White Head from Peaks Island,
Peaks Island, Me.

The military also left its mark on the islands. Fort Levett was built on Cushing Island in 1898 as part of the government's efforts to improve defense of the East Coast during the Spanish-American War. (Author's collection.)

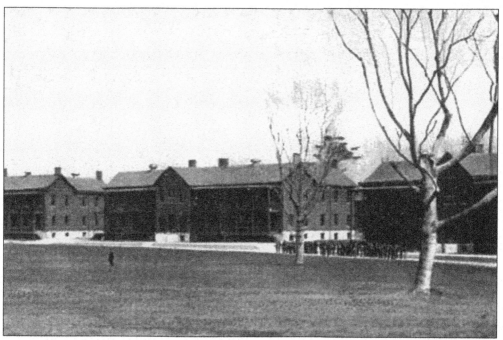

Fort McKinley on Great Diamond Island was also built in 1898. Both forts were upgraded during World War I and again during World War II. (Author's collection.)

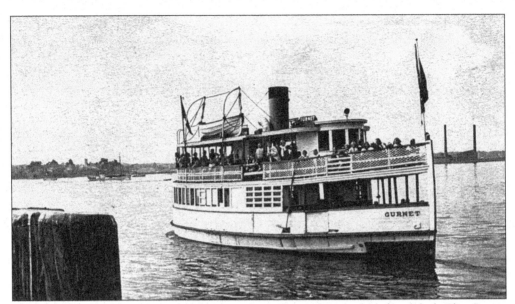

As the 1920s opened, some of the old steamboats were converted to diesel fuel. The *Gurnet* continued her runs down the bay for many years after being converted. (Author's collection.)

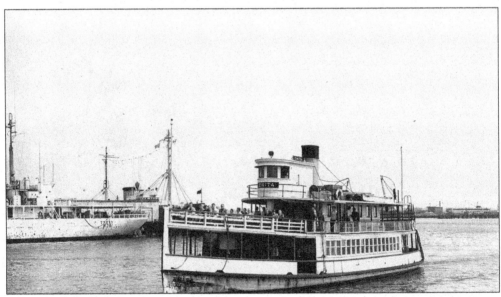

The *Emita*, shown here steaming into Custom House Wharf in Portland, began her runs in 1883 as a steamer and was retired in the early 1950s as a diesel. (Author's collection.)

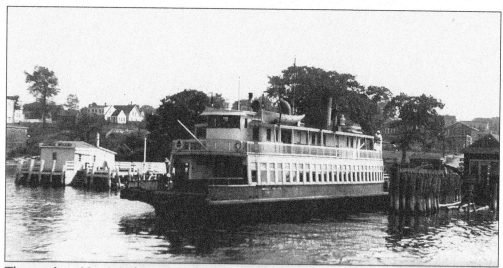

The car ferry *Nancy Helen* joined the Casco Bay fleet in June 1936, making several runs a day to Peaks Island. Owner Bud Cohen named the ferry after his young daughter. (5th Maine Regiment Museum collection.)

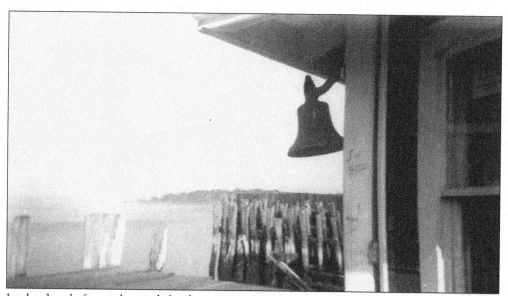

In the days before radar, each landing was equipped with a fog bell, which someone onshore would ring in order to help guide the ferry into the landing. This bell hung at Forest City Landing on Peaks Island. (Author's collection.)

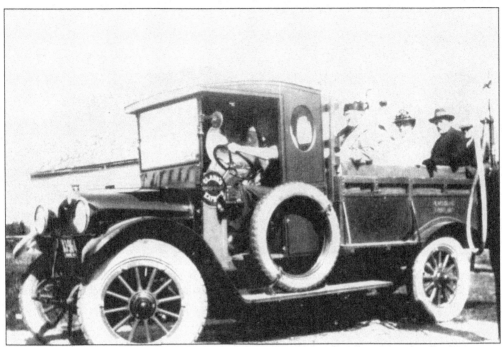

Although islanders relish living apart from the rest of the world, they eagerly embrace modern amenities for pleasure and work. Here, Mr. Clark takes a group for a spin in his new truck c. 1930. Clark owned a Peaks Island delivery service, Clark's Express, for many years. (Author's collection.)

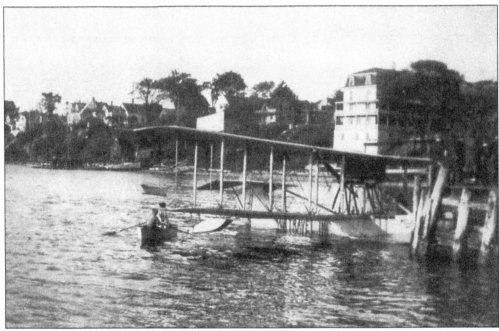

Flight came to Peaks Island in 1927 with the arrival of a Curtis bi-wing float plane, which landed at Forest City Landing. (5th Maine Regiment Museum collection.)

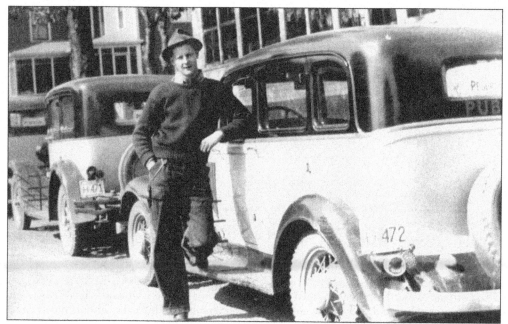

The Pedersen brothers, Sam and Chris, revived the family transportation business started by their great-grandfather, Capt. William S. Trefethen, in the 1890s. The brothers operated a fleet of taxis in the 1930s. Here, a dapper Ken Cameron leans against one of the taxis parked "downfront" on Peaks Island. (5th Maine Regiment Museum collection.)

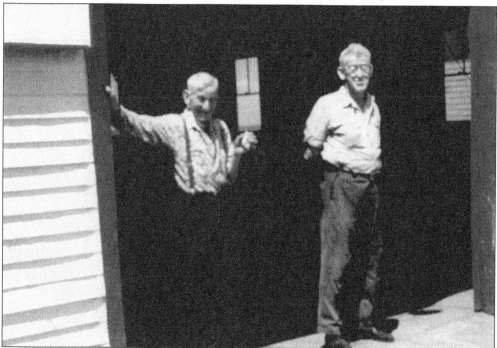

Sam (left) and Chris also owned the Peaks Island Garage, selling heating fuel and gasoline. The brothers were two of the island's best-loved residents. Sam always had a ready smile and kind word for everyone, while Chris was more reserved. (Author's collection.)

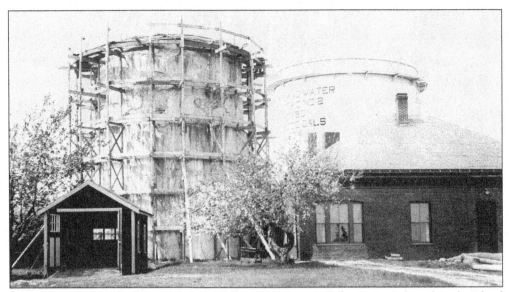

The Portland Water District first piped Sebago Lake water to the Diamonds and Peaks Island in 1920. Great Diamond had a large cistern for water storage, while Peaks, with its much larger population, had two water storage tanks. (Maine Historic Preservation Commission collection.)

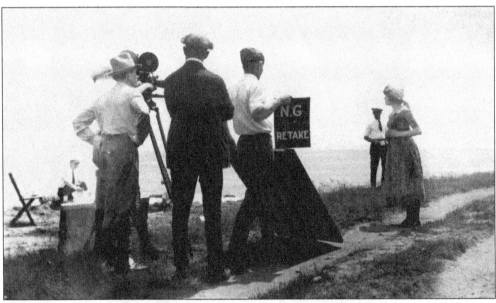

Hollywood came to Peaks Island in the 1920s. Lifelong summer resident and director extraordinaire John Ford (behind the camera) filmed a movie on the island's backshore. The identity of the actress is unknown, though some say it is Gloria Swanson. (5th Maine Regiment Museum collection.)

During the Roaring Twenties and the depression years that followed the 1929 stock market crash, islanders went about their everyday lives. Charles Yeaton was a fixture on Cliff Island. For many years, he maintained the island's gravel roads. (Cliff Island Historical Society collection.)

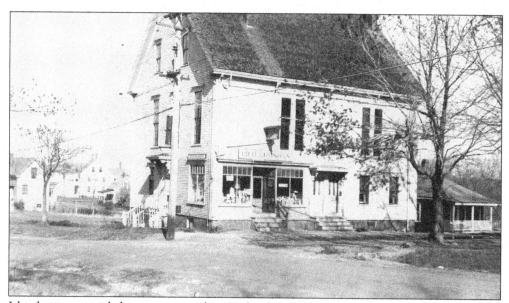

Island stores provided necessary supplies. Richardson's was one of six mom-and-pop stores on Peaks Island. (Maine Historic Preservation Commission collection.)

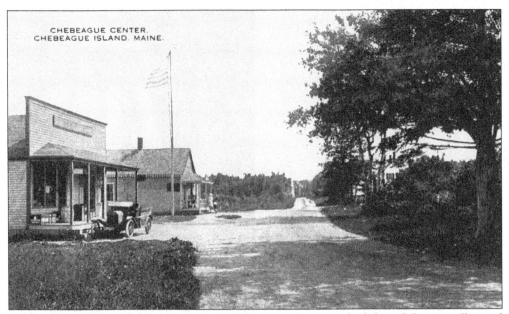

Chebeague residents were served by Leonard's Store, seen here on the left, and the post office and Henry Bowen's Store, in the building behind the flagpole. (Donna Miller Damon collection.)

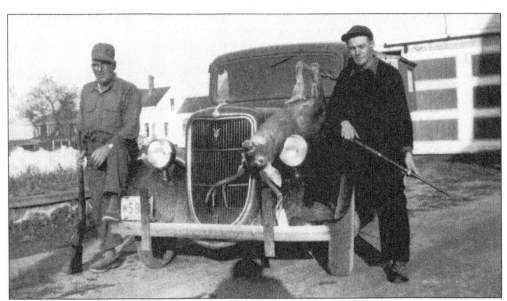

Many islanders hunted in the north woods of Maine to supplement their families' food supply. Arthur Ross (left) and Fred Stephenson show off the results of their hunting expedition here. (Author's collection.)

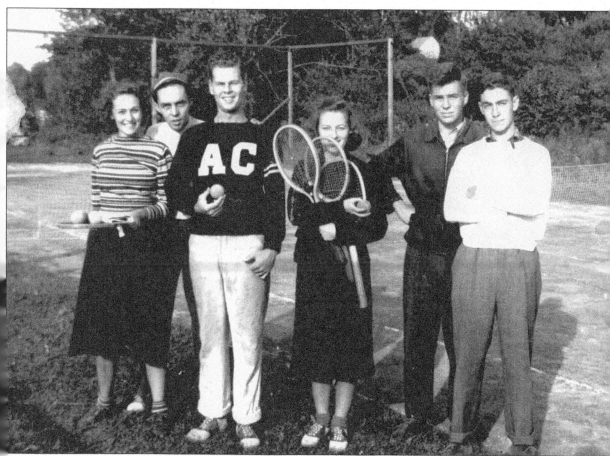

Island teenagers preferred to spend their time playing tennis. Pictured here from left to right are Betty Purvis, Leroy Snowden, Don Skillings, Nancy Randall, Russ Webber, and Jack Keoughan at the Trefethen-Evergreen Improvement Association clubhouse on Peaks Island. (5th Maine Regiment Museum collection.)

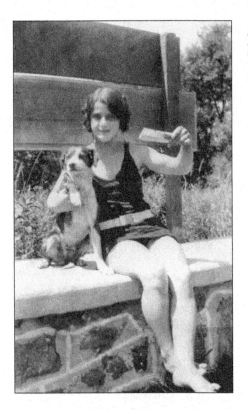

As always, going to the beach remained a popular summer pastime. The identity of this bathing beauty and her dog are unknown, as is the location of the beach. (Author's collection.)

Youngsters on Cliff Island presented their version of Shakespeare's *A Midsummer Night's Dream* in the 1930s. (Cliff Island Historical Society collection.)

During the winter of 1932–1933, Mr. Becker arrived on Peaks Island with his own means of on-island transportation. He felled trees on a site at Evergreen, cut the lumber, and built a log cabin at the end of Woods Road. (Author's collection.)

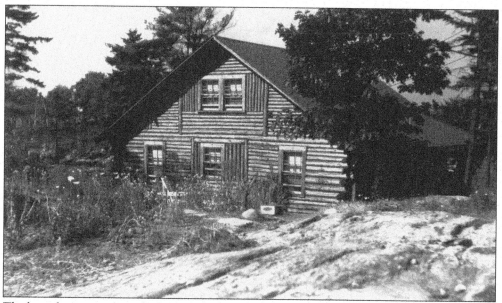

The log cabin remains perched on a cliff overlooking Pumpkin Knob, a testament to Mr. Becker's building skills. (Author's collection.)

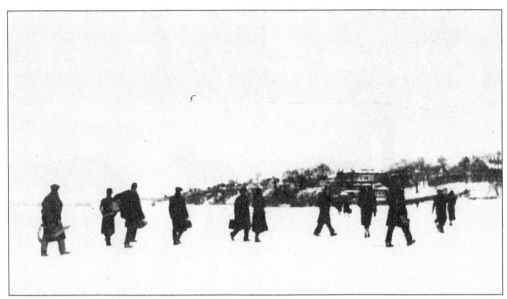

Never let it be said that snow and ice keep islanders from their appointed rounds. During the winter of 1934, a heavy ice pack prevented the ferries from landing at the Peaks Island wharf. Hardy island folks trudged across the ice to and from House Island to catch the boat for work and school. (Author's collection.)

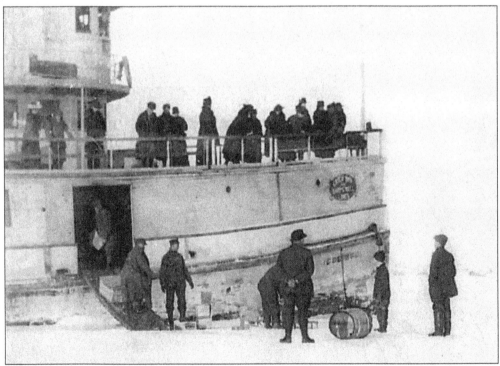

That same winter, heavy ice also prevented the ferries from landing at the Cliff Island wharf. Islanders had to drag their freight across the ice to shore. (Cliff Island Historical Society collection.)

The ferry *Swampscott* was a victim of the ice pack in 1934. She sunk at her berth at Forest City Landing on Peaks Island with her smokestack rising high above the ice. In the background, the cutter *Ossipee* is attempting to break up the ice. (5th Maine Regiment Museum collection.)

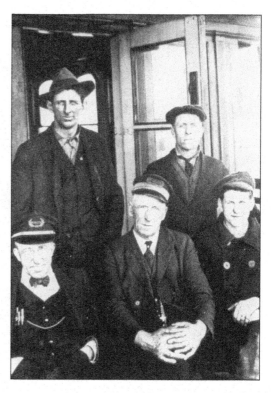

The crew of the *Swampscott* is pictured here in happier times. Seated are Walter Crandall (left), Oscar Seabury (center), and an unidentified person. Standing are Harold Newell (left) and Bill Cushing. (5th Maine Regiment Museum collection.)

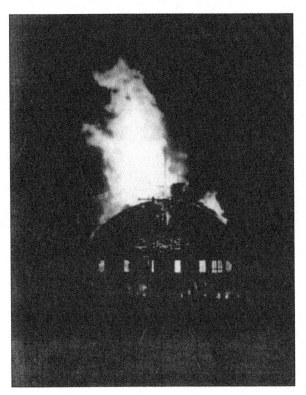

Because firefighting efforts were often hampered by high winds and a restricted water supply, many of the hotels, cottages, and businesses on the islands were eventually destroyed by fire. Peaks Island's Gem Theatre burned to the ground in a spectacular fire in 1934. (5th Maine Regiment Museum collection.)

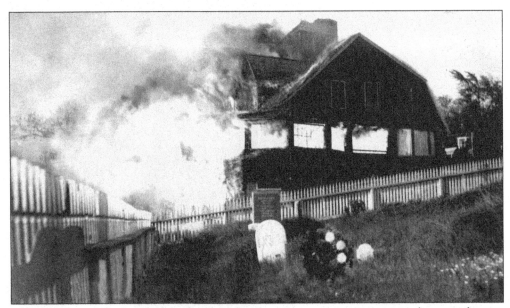

Two years later, Mrs. Jewett, who lived on Brackett Point, was attempting to burn moth nests out of her trees with oil soaked rags on a windy day. Her efforts resulted in the destruction of 17 buildings in the Forest City section of Peaks Island. (Author's collection.)

Six

ISLANDS AT WAR
1941–1946

The outbreak of World War II brought many changes to the islands in terms of landscape and population. Liberty ships were built in South Portland; the North Atlantic fleet was headquartered in Portland Harbor; convoys of ships headed for Europe after refueling at Long Island in preparation for the dangerous journey across the North Atlantic; German U-boats prowled the waters of the Gulf of Maine. Thousands of soldiers and sailors were stationed at existing and new bases on the islands—between 800 and 900 enlisted men and officers on Peaks Island alone. Security in Casco Bay and Portland Harbor was a prime concern.

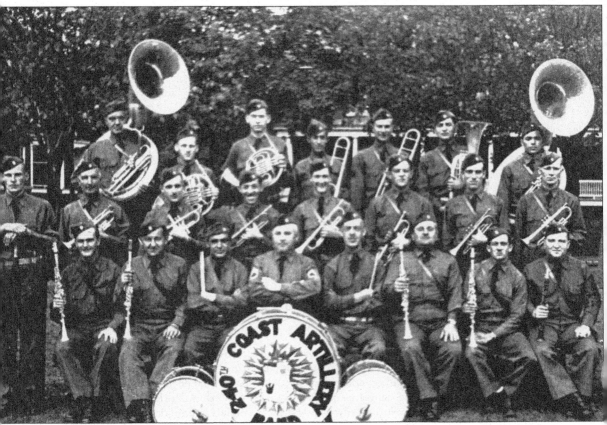

Following the declaration of war in December 1941, the government strengthened the defense system in Casco Bay. Existing bases were upgraded and new bases were added. The 240th Coastal Artillery and the 8th Coastal Artillery were assigned responsibility for defending the bay. Here, unidentified members of the 240th's band pose for a group photograph. (5th Maine Regiment Museum collection.)

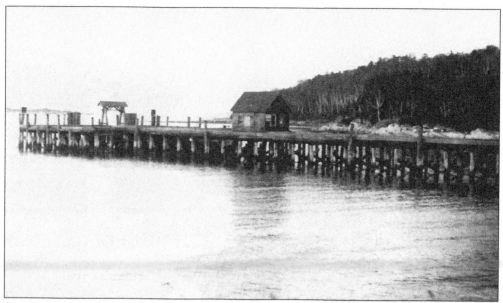

Fort Levett on Cushing Island was expanded and upgraded with the latest military technology. Personnel and equipment were unloaded at Government Wharf, on the northern shore of the island. (National Archives collection.)

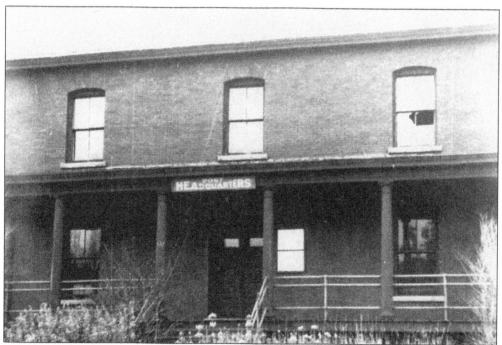

The post headquarters was located in one of Fort Levett's original brick buildings, constructed in 1898. (National Archives collection.)

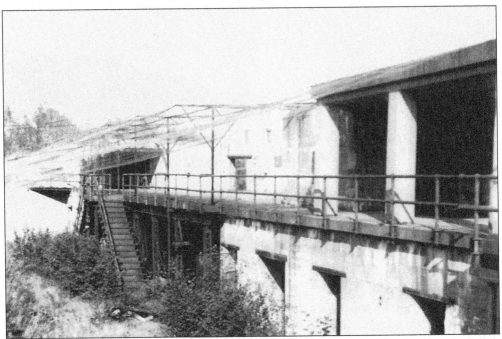

Battery Bowdoin mounted three 12-inch, breech-loading rifled guns on disappearing carriages. Each fired a 975-pound projectile to a maximum range of 10 miles. (National Archives collection.)

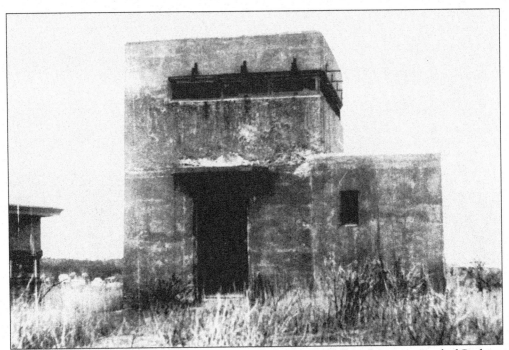

The World War II observation station built atop Whitehead Cliff on the eastern end of Cushing Island is visible from many points around the southern part of Casco Bay and Portland Harbor. (National Archives collection.)

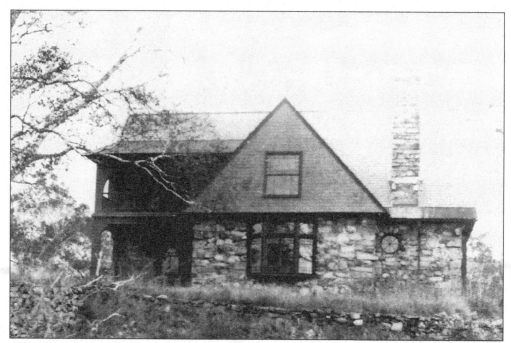

The military also made use of private cottages on the island. This stone cottage served as a club for the officers stationed at Fort Levett. (National Archives collection.)

Maj. Augustus S. Hocker served as the commandant at Fort Levett. Several years after the war ended, with the rank of colonel, he retired to his cottage on Peaks Island. (5th Maine Regiment Museum collection.)

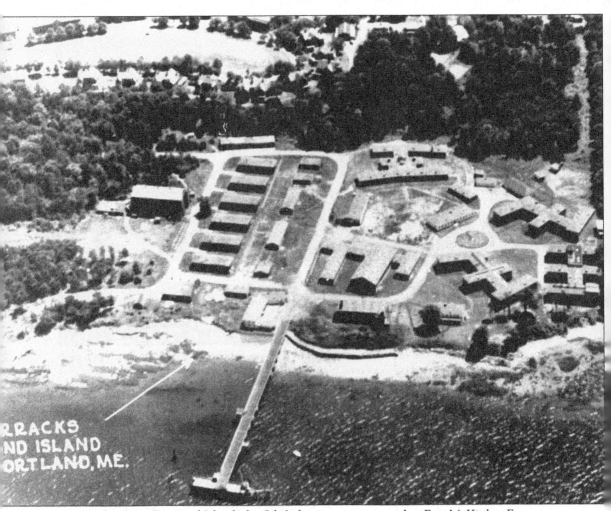

RRACKS
ND ISLAND
ORTLAND, ME.

On nearby Great Diamond Island, the 5th Infantry was garrisoned at Fort McKinley. For some inexplicable reason, the 5th also included a number of cavalry soldiers and their horses. A few islanders recall being allowed to ride the horses across the sandbar that connects Little and Great Diamond Islands at low tide. (National Archives collection.)

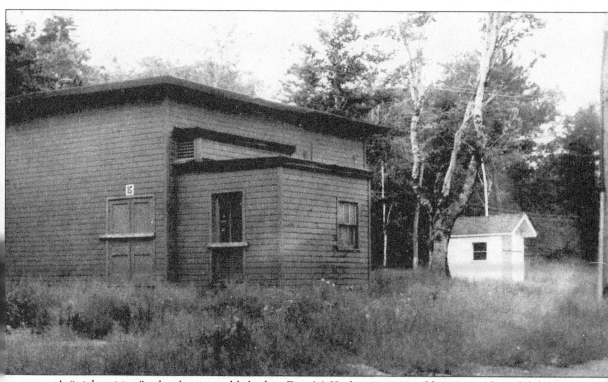

A "night vision" school was established at Fort McKinley to train soldiers to work and fight effectively in the dark. (National Archives collection.)

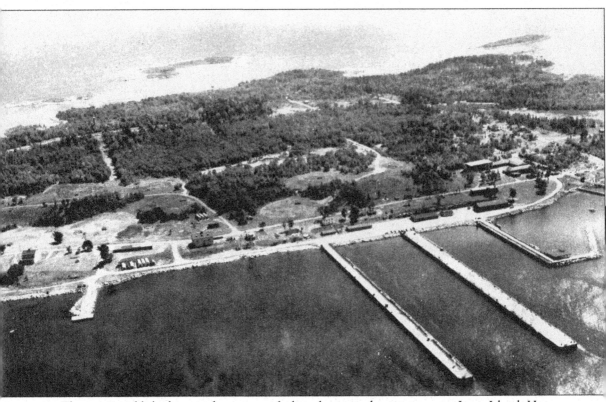

The navy established its northernmost refueling depot on the east coast on Long Island. Huge underground oil-storage tanks were installed, and wharves long enough to accommodate many types of vessels were built on the northern shore of the island. (National Archives collection.)

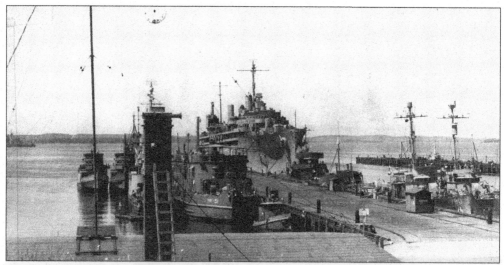

Shown here are several vessels of various sizes berthed at one of the Long Island navy wharves. (National Archives collection.)

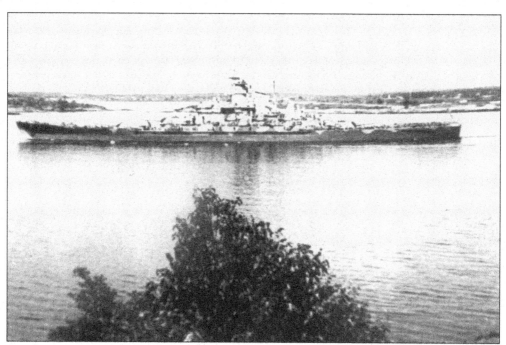

After refueling, convoys of battleships, cruisers, destroyers, and merchant ships formed in the anchorage between Great Diamond and Long Islands for the dangerous voyage across the North Atlantic to Europe. An unidentified battleship is seen here exiting Hussey Sound between Peaks and Long Islands. (5th Maine Regiment Museum collection.)

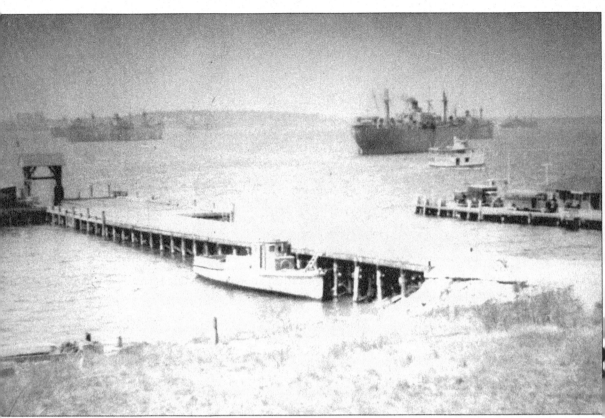

The New England Shipbuilding Corporation and the Todd-Bath Yards in South Portland built 234 liberty ships to help carry supplies and troops to Europe, North Africa, and the Pacific. The two liberty ships pictured here are moored off the western shore of Peaks Island in preparation for joining a convoy. (5th Maine Regiment Museum collection.)

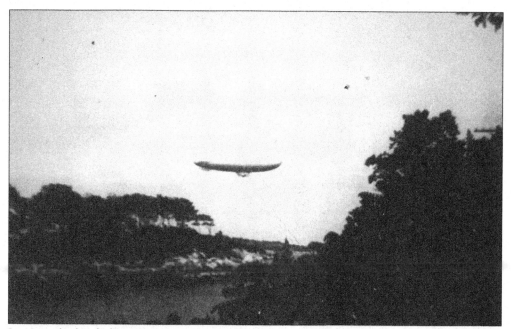

In 1944, the battleship *Iowa* ran aground on Soldiers Ledge in Hussey Sound, damaging 75 feet of her keel. The navy then placed navigation aids on the islands surrounding the sound to help guide ships safely into the anchorage. One aid was a blimp tethered to Pumpkin Knob, a small island at the northern end of Peaks Island. (5th Maine Regiment Museum collection.)

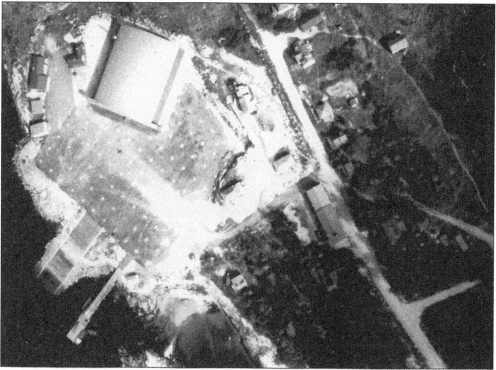

The navy also established a seaplane base on Long Island. (National Archives collection.)

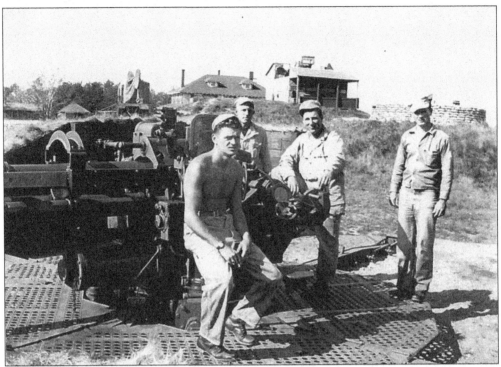

A 40-millimeter gun was placed on the east end of Chebeague Island during the war. These unidentified coastal artillery men were assigned to maintain and man this defensive position. (Martha Hamilton collection.)

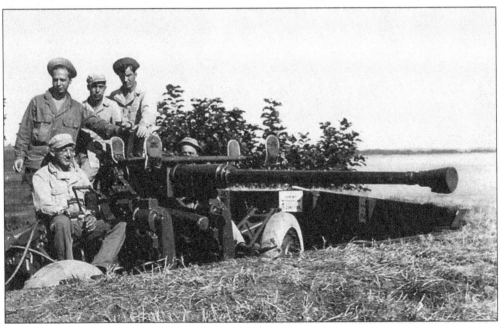

A 90-millimeter mobile gun was also placed on the east end of Chebeague for the duration of the war. It, too, was manned by these unidentified coastal artillery men. (Martha Hamilton collection.)

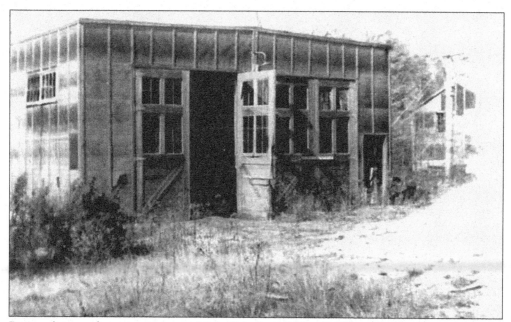

During the war, the government established the Jewell Island Military Reservation as part of the defense system in Casco Bay. The reservation was a fully equipped base, which included this fire station. Jewell Island is now a state park. All that remains of the reservation are the concrete towers, gun emplacements, and batteries. (5th Maine Regiment Museum collection.)

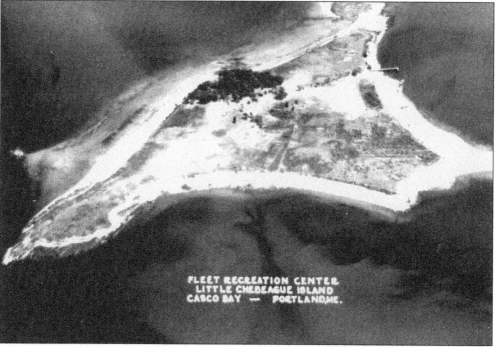

The navy maintained a fleet recreation center on Little Chebeague Island for its personnel. Little Chebeague is now a state park accessible by small boat or, at low tide, by the sandbar that connects it to Chebeague Island. (National Archives collection.)

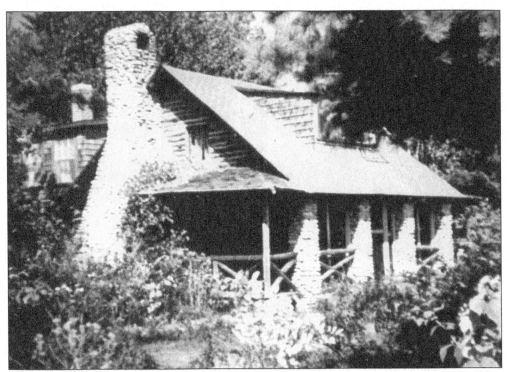

The government chose Peaks Island as the site of the largest military base in Casco Bay during World War II. About 180 acres were taken by eminent domain; existing cottages were demolished or renovated for military use, and roads and utilities were installed. The Blackman farmhouse, a log-and-stone structure overlooking Hussey Sound, was one of those razed. (5th Maine Regiment Museum collection.)

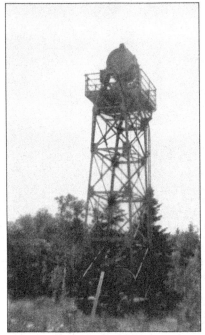

The "disappearing" spotlight installed on the island by the military in World War I was used again during World War II. The counterweight at the light's base could be moved in one direction to lay the spotlight on its side when not in use. The counterweight could then be moved back to its original direction to raise the spotlight as needed. (National Archives collection.)

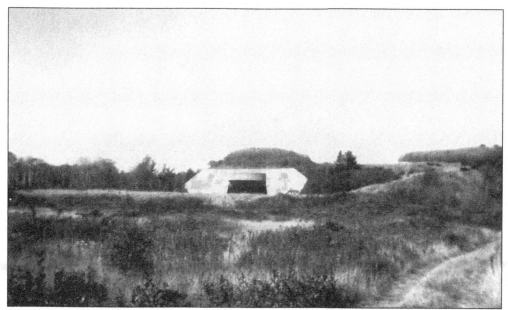

Battery Steele, the largest gun battery ever built in Maine, is 300 feet long and mounted two 16-inch guns, which could fire a 2,000-pound shell 26 miles. The guns were controlled by a computer in the plotting room building, located around the corner from the battery. This battery was designed to protect the coast, from Popham in the north to Kennebunk in the south. (National Archives collection.)

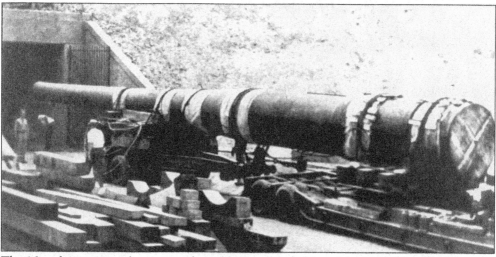

The 16-inch guns were the same as those found on battleships of that time. They were brought to the island by barge and dragged on trailers to the battery, tearing up the roads along the way. Note the size of the men compared to the gun as it is being moved into place. (5th Maine Regiment Museum collection.)

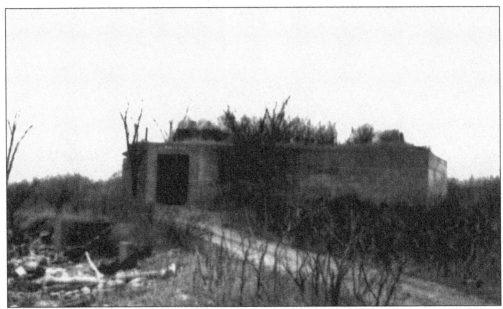

During the war, mines were laid throughout Casco Bay. They were controlled from the mine casemate, a large steel-reinforced concrete building topped with several feet of earth. It was situated on the northeast shore of Peaks Island, overlooking Hussey Sound. (National Archives collection.)

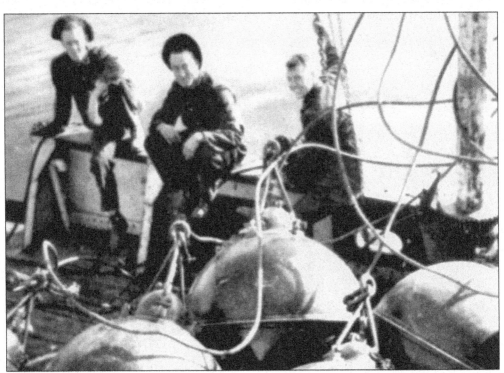

Laying mines properly was tricky business. Here, three unidentified sailors prepare to go to work. The mines are the large cylindrical objects in front of the men. (5th Maine Regiment Museum collection.)

98

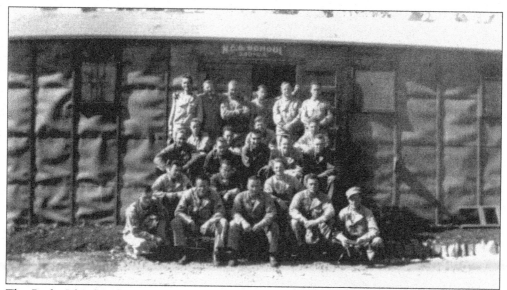

The Peaks Island Military Reservation was home to a noncommissioned officers' school and a first sergeants' school. Soldiers were trained for those ranks and then reassigned elsewhere. (5th Maine Regiment Museum collection.)

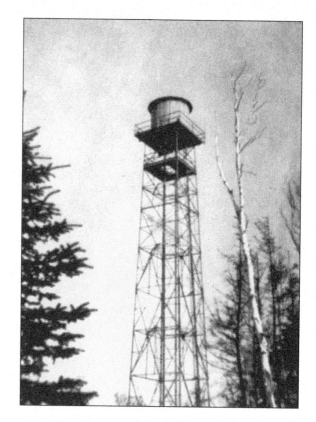

The reservation was equipped with the most up-to-date technology, including a new invention—radar. The radar tower was disguised to look like a water tower. An elevator transported the technicians to and from the radar room at the top of the tower. (5th Maine Regiment Museum collection.)

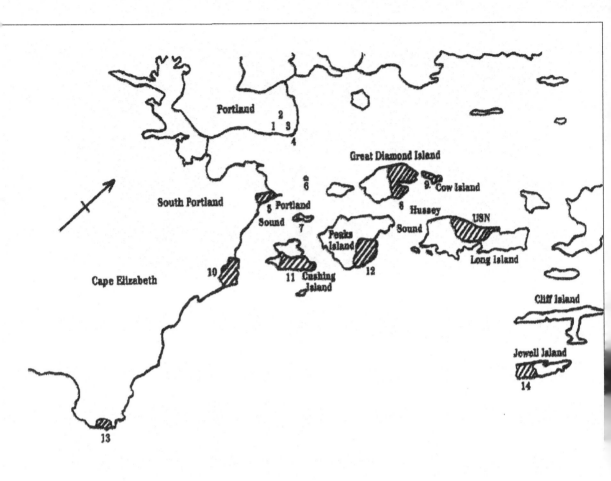

This map shows the locations of the following coastal artillery and navy bases in southern Casco Bay during the war years: Fort Burrows (1), Fort Sumner (2), Fort Allen (3), Fort Lawrence (4), Fort Preble (5), Fort Gorges (6), Fort Scammel (7), Fort McKinley (8), Fort Lyon (9), Fort Williams (10), Fort Levett (11), Peaks Island Military Reservation (12), Cape Elizabeth (Two Lights) Military Reservation (13), and Jewell Island Military Reservation (14). (Author's collection.)

The military provided many services for the soldiers and sailors stationed in Casco Bay and the surrounding towns, including medical care. However, with few casualties and many local doctors serving overseas, the military doctors often treated civilians as well. Dr. Eugene Fogg directed the 240th's medical team. Following the war, he served on the staff of Walter Reed Medical Center in Washington, D.C., for many years before retiring to his Peaks Island cottage. (5th Maine Regiment Museum collection.)

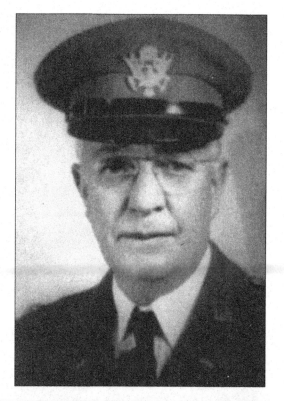

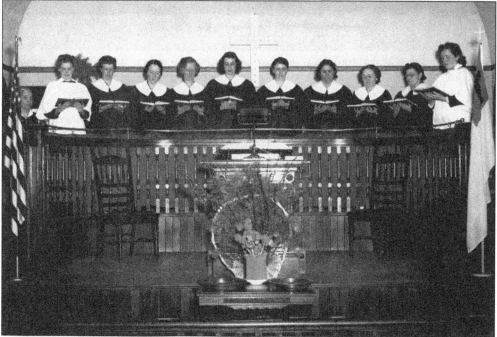

Despite the changes wrought by war, islanders continued with their daily activities. Here, unidentified members of the Brackett Memorial Church on Peaks Island practice for Sunday services. (5th Maine Regiment Museum collection.)

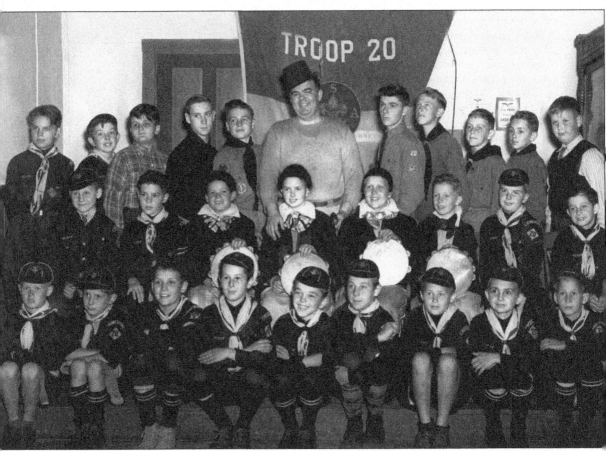

Scouting played an important role in the lives of island youths. Troop 20 presented a minstrel show for parents' night in 1944. The scouts are, from left to right, as follows: (front row) Thomas Foley, Francis Earley, Joseph Earley, Clyde Sanborn, Stanwood Crandall, Rodney McCollister, John Foley, Benjamin Doe Jr., and William Mackie; (second row) Aubrey Lancaster, Alan Ward, Ronald Leonard, Richard MacDaid, Robert Carlson, Bryan Somers, Kenneth Mullin, and Elbridge Boyle; (third row) Norman Turner, Walter Crandall, Richard Briggs, Richard McCollister, Robert Ward, Ralph Purington (Scoutmaster), Lawrence Hasson, Jack Crawford, Gordan Woodbury, Edward Gienty, and Walter Beesley. (5th Maine Regiment Museum collection.)

Summer stock companies performed at the Greenwood Garden Playhouse each summer. The handsome young man stretched out on the ground in front of the group is actor Martin Landau. (5th Maine Regiment Museum collection.)

Peaks Islanders indulged in their love of the theater by staging *Rosemary of the Island*, a play written by islander Kitty Grant. Teenagers would vie for the role of Rosemary and her star-struck paramour. In costume here are three unidentified ladies and Arlette and William Frellick, on the right. (5th Maine Regiment Museum collection.)

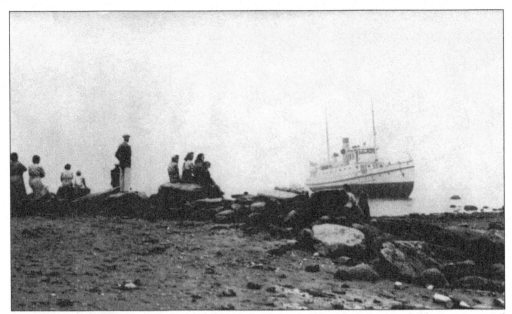

Wartime precautions did not prevent maritime disasters. The *Governor Bachelder* ran aground on Peaks Island *c*. 1940. (Author's collection.)

In 1948, the eighth-grade graduating class at the Peaks Island School was a fairly small one—just 12 students. Louis Alexander is the young man on the right in the back row. (5th Maine Regiment Museum collection.)

In contrast, the kindergarten class of 1948 was much larger. The students are, from left to right, as follows: (front row) Wayne Tracy, Paula Strasser, Michael Metcalf, Nancy Lee Bray, George Vincent Jr., Paula Parmenter, and Kathleen Howland; (second row) Paul Brown, Robert Leonard, April King, Bradley Barriteau, Kathleen Mulcahy, Stephen Scribner, and Ernest Kimball; (third row) Owen O'Donnell, Lois Preston, Jeffry Mullin, teacher Eleanor O'Connor, Maureen Feeney, Sharon Brackett, and Meldeau Whitton Jr. (5th Maine Regiment Museum collection.)

Throughout the 1940s, the Casco Bay Light and Power Company supplied electricity to the islands. Each military base had its own power-generating facilities but did rely on Casco Bay Light and Power to meet some of its electricity needs. The company was acquired by Central Maine Power in the 1960s. (Author's collection.)

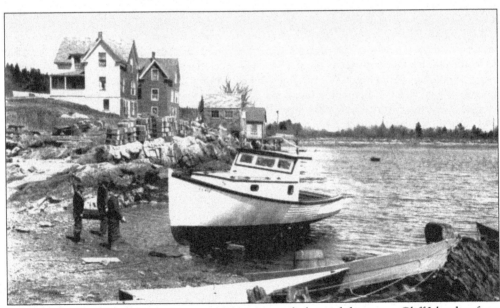

The war may have limited access to some fishing grounds, but it did not stop Cliff Islanders from pursuing a traditional occupation—boatbuilding. Here, three men admire a nearly complete lobster boat, their traps stacked and ready to be set. (Cliff Island Historical Society collection.)

Seven

A CHANGING WORLD, A CHANGING BAY

1950–2000

Island life returned to normal with the departure of the soldiers and shipyard workers. Islanders who served overseas came home, eager to start careers and families. The postwar prosperity brought new residents, both year-round and seasonal. The decades that followed brought, in rapid succession, a diversity of people—hippies, yuppies, granolas (the old-time islanders' term for a hippie with money), and retirees from around the country. Regardless of where new residents hail from, they share a love of the natural beauty of the bay and islands, the relaxed lifestyle, and the old-fashioned sense of community still found on the islands of Casco Bay.

The war years left their mark on the islands in many ways. The landscape was forever changed; the brick-and-concrete structures have become landmarks in the bay. Like many young island families in the 1950s, Marge Erico and her children often trekked to Battery Steele for an afternoon picnic. (Author's collection.)

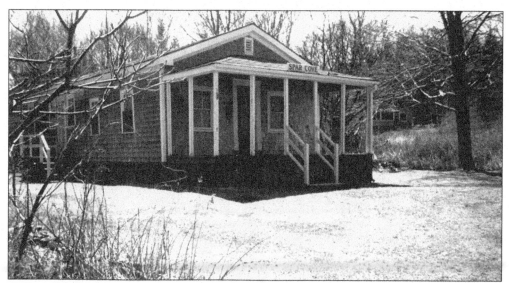

A few of the military buildings were moved and converted to civilian use. This building, a former barracks, was renovated into a comfortable summer cottage, aptly named Spar Cove. It sits on and is named for Spar Cove on Peaks Island. (Author's collection.)

An oversized shed from the reservation was moved and attached to the rear of this cottage on Elizabeth Street on Peaks Island to become a bedroom for the owners' daughters. (Author's collection.)

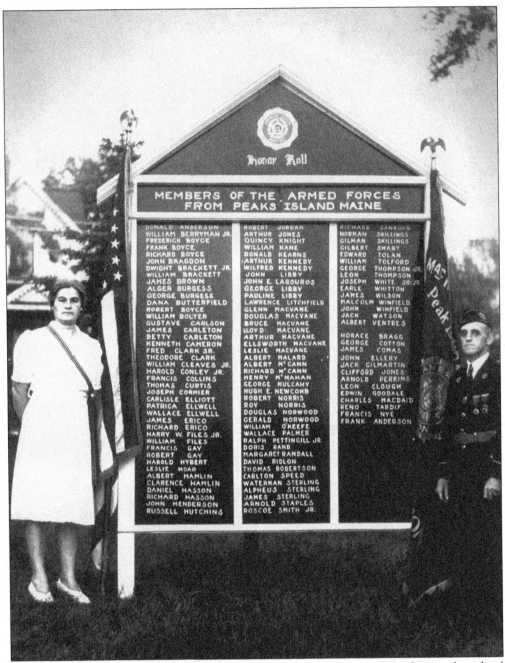

The Randall-MacVane Post on Peaks Island erected this monument to honor the island men and women who served in the military during the war. Post commander Cyril Hill and auxiliary president Etta MacVane officiated at the dedication ceremony. (5th Maine Regiment Museum collection.)

Life slowly returned to normal. Returning veterans married and started families. Other young families, both seasonal and year-round, joined them. After serving six years in the Pacific, navy veteran Richard Erico resumed his daily swims during the warmer months. (Author's collection.)

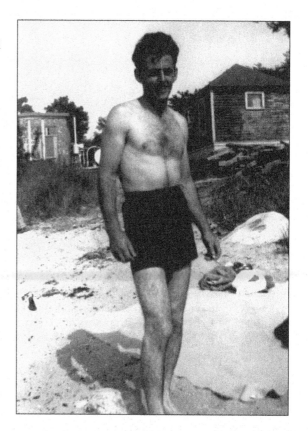

Roger's Spa on Long Island provided plenty of ice cream and other goodies for the children of the baby boom generation. (Author's collection.)

Bennett's Store on Chebeague Island supplied residents with necessities, as well as a place to meet neighbors and talk about the issues of the day. (Donna Miller Damon collection.)

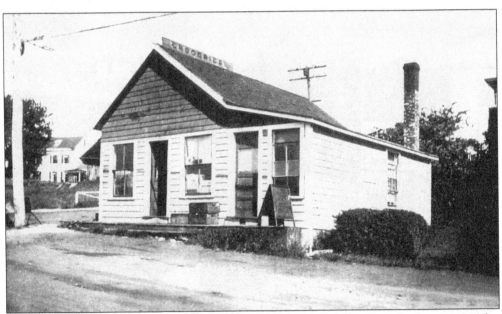

Andy Englund's store on Peaks Island served up fresh doughnuts, hot from the fryer, on Sunday mornings. People lined up outside early in the morning, so as not to miss out on "the best doughnuts anywhere." (Author's collection.)

"The Store" on Cliff Island, owned by Buck Seymour, offered a wide variety of provisions to residents—an important service, since the ferry ride to Portland is over an hour one-way. (Author's collection.)

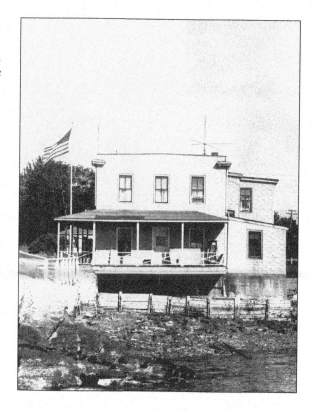

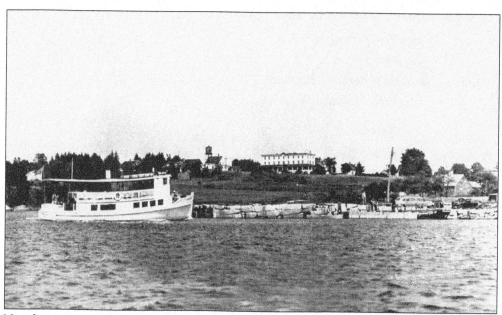

New ferries appeared in Casco Bay after World War II. The *Nellie G III*, shown here approaching the float at the stone wharf on Chebeague Island, ran on the inner bay route from 1947 through 1959. (Jim Millinger collection.)

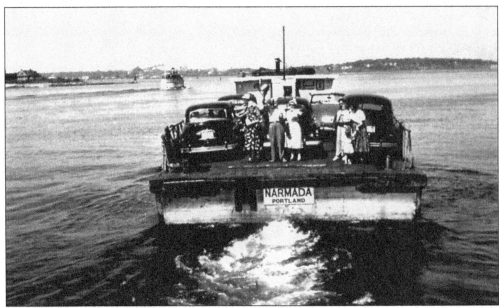

The *Narmada* transported vehicles and sometimes passengers on the Peaks Island–Portland route. She was basically a barge with a wheelhouse. (Author's collection.)

PEAKS ISLAND
CAR FERRY SERVICE, Inc.

Phone: Peaks Island 16

Automobile service between **Portland** and Peaks Island

RATES

Pleasure Cars	$1.00	Tax .03	Total	$1.03
½ Ton Truck	1.50	" .05	"	$1.55
1 Ton to 2 Ton Truck	2.50	" .08	"	$2.58
3 Ton to 5 Ton Truck	4.00	" .12	"	$4.12

Leaving Portland for Peaks Island on the the hour as demands require.

Returning to Portland on the half hour from Peaks.

Schedule Subject to Change

YOUR PATRONAGE WILL BE APPRECIATED

As seen in her schedule, the *Narmada* made frequent trips to Peaks Island at very reasonable rates—a far cry from today's rates, which start at $65 for a passenger vehicle. She was owned by Sam Howard of Peaks Island. (5th Maine Regiment Museum collection.)

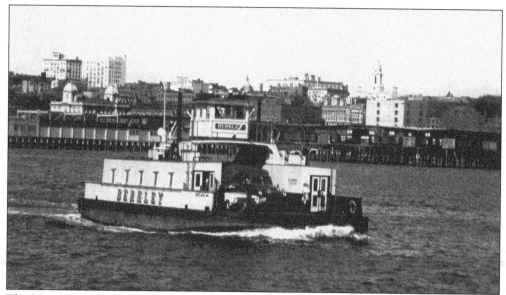

The *Narmada* was followed by the *Berkeley*, a well-loved ferry equipped with a double wheel in the pilothouse. This double wheel allowed the *Berkeley* to make the round-trip to Peaks Island without having to turn around. (Author's collection.)

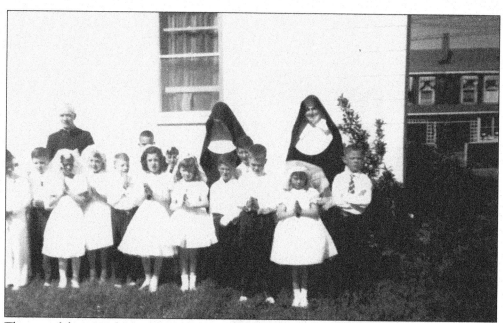

The size of the 1957 first communion class at St. Christopher's Church reflects the importance of organized religion in the lives of families in the years after World War II. Shown with the children are Fr. John Minehan and two unidentified Sisters of Mercy. (Author's collection.)

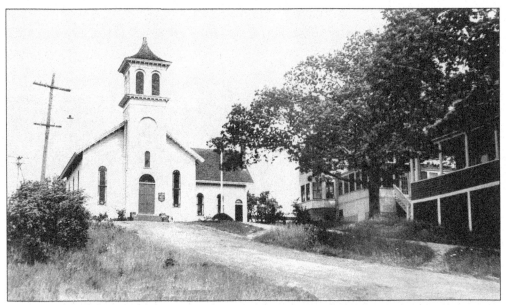

The Brackett Memorial Church on Peaks Island made changes to accommodate its growing congregation. In 1956, the old parsonage (behind the tree) was demolished to make way for the addition of the church hall. A home a short distance away was renovated as the new parsonage. (Maine Historic Preservation Commission collection.)

Long Islanders continued to worship at the Evergreen Methodist Church, built in 1879. The church remains a focal point of activity for the community. (Author's collection.)

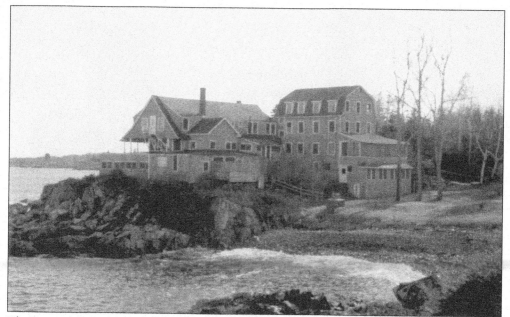

The Sisters of Notre Dame inherited Ye Headland Inn in 1940. They maintained it as a vacation house, St. Anthony's by the Sea, until 1982, when it burned. The inn was one of 16 hotels on Peaks Island during the "Coney Island" era, from 1880 to 1920. (Author's collection.)

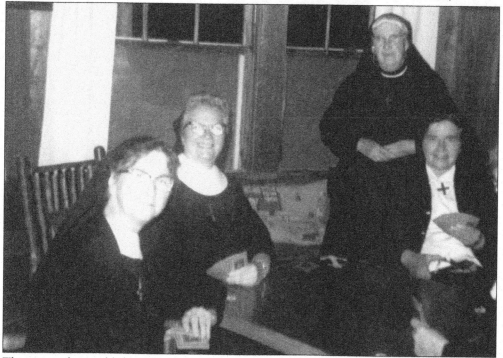

The sisters also established a year-round mission on the island. They were a friendly group who welcomed everyone to their large home, St. Joseph's by the Sea. Seen enjoying a card game are, from left to right, Sr. Rosina Gallahue, Sr. Ann Augusta Cullen, and two unidentified sisters. (Author's collection.)

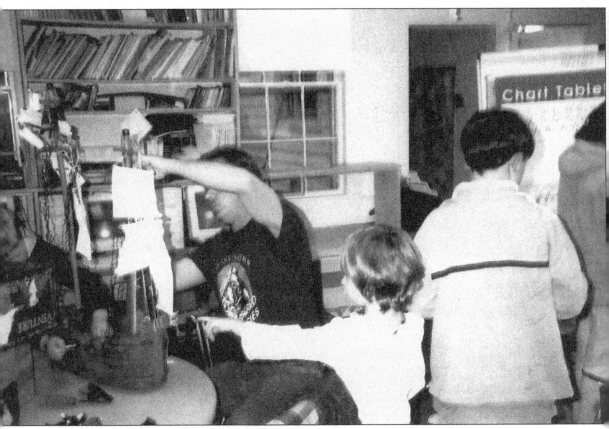

Island life was very much centered around the needs of the large population of youngsters. Cliff Island's one-room school remains one of the few one-room schools in Maine. Here, students are constructing a model of a sailing vessel. (Cliff Island Historical Society collection.)

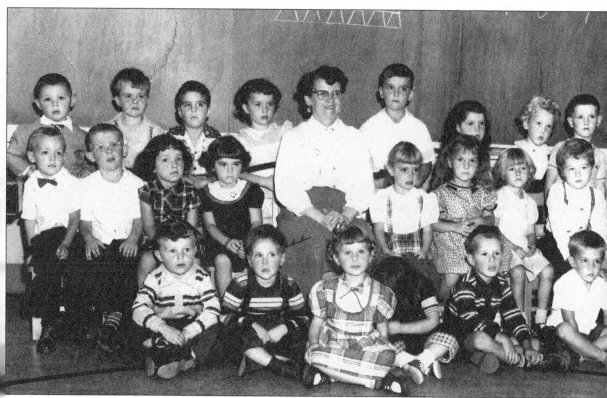

Peaks Island boasted nearly 200 students in kindergarten through grade eight. The kindergarteners seen here seem a bit apprehensive about their first day at school in September 1954. They are, from left to right, as follows: (front row) Daniel Hansen, William McCann, Betty Ann Boyle, Janice Slezinger, Richard Ivers, and Robert Cleland; (second row) Norman Sargent, James Henry, Lynn Norris, Jean McIntyre, teacher Eleanor O'Connor, Kimberly Erico, Marcy Parkhurst, Kathleen Kennedy, and Roger Agger; (third row) Francis Van Ness, Charles Boyce, Jerry Angell, Karen McDowell, John DeFlumeri, Kathleen Feeney, Mary Bradford, and William Briggs. (Author's collection.)

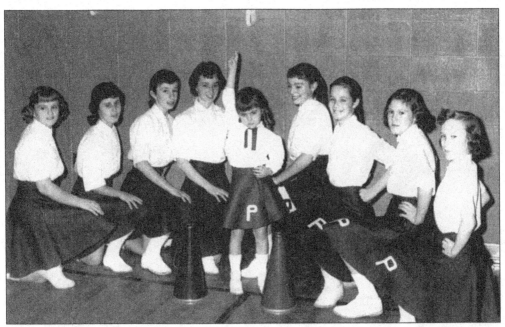

The seventh and eighth grades at the Peaks Island School had basketball and baseball teams, which played against teams from Portland area junior high schools. The school's cheerleaders pose here for a group photograph in the early 1960s. From left to right are Linda Scribner, Didi Butterfield, Linda Ivers, Donna Moore, mascot Ellen Latham, Diane Green, Katie Sullivan, Nancy Dube, and Marilyn Burke. (Author's collection.)

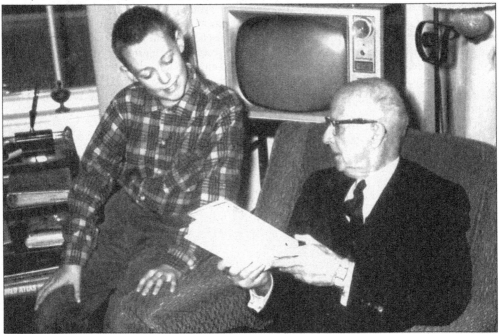

Famed arctic explorer Adm. Donald Macmillan visited the Peaks Island School in 1960, bringing many artifacts from his voyages on the schooner *Bowdoin*. Norman Sargent listens intently as the admiral shows him a document. (5th Maine Regiment Museum collection.)

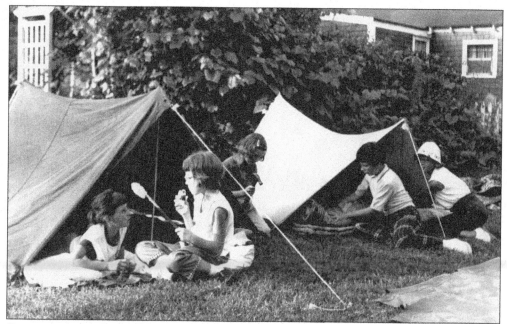

Scouting remained a popular activity for island youths. Here, members of Girl Scout Troop 76 show off their outdoor skills at an overnight camp-out. They are, from left to right, Betty Ann Boyle, Beverly Conley, Andrea McCracken, Linda Levesque, and Kim Erico. (Author's collection.)

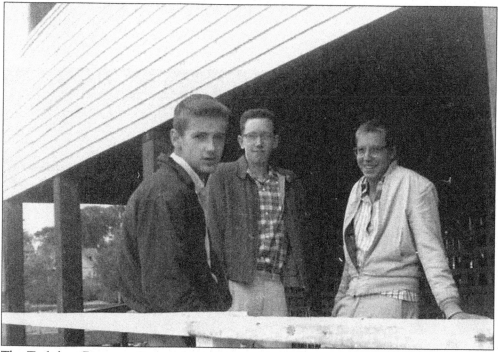

The Trefethen-Evergreen Improvement Association clubhouse remained a favorite place for Peaks Island teenagers to meet during the summer months. Pictured here are, from left to right, Steve MacIsaac, Tom Hennessey, and Paul Yarrington. (Author's collection.)

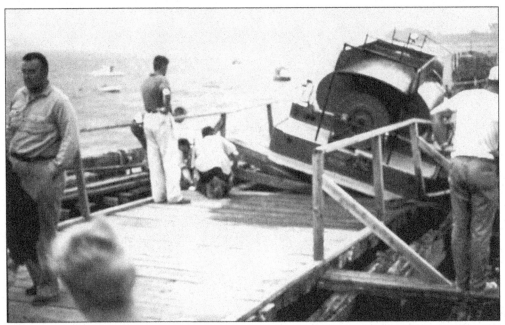

The post–World War II decades were not without excitement on the islands. In 1964, a fire truck fell through Jones Landing, Peaks Island, while attempting to board the ferry for its annual servicing in Portland. Shortly thereafter, the landing was closed to the public, due to its unsafe condition. (Author's collection.)

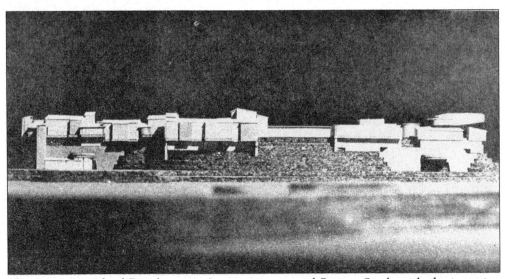

The Casco Bay Island Development Association acquired Battery Steele with the intention of developing it as a retreat and conference center for international diplomats. Shown here is the architect's drawing for the structure to be built atop the battery. (5th Maine Regiment Museum collection.)

Hollywood returned to Casco Bay in the 1980s, when *The Whales of August* was filmed on Cliff Island. Written by Peaks Islander David Berry, the film starred Bette Davis, Lillian Gish, Ann Southern, and Vincent Price. The storyline centered on two sisters from Philadelphia who had spent every summer of their lives at their island cottage. Here, the cast and crew pose for a group photograph. (Author's collection.)

As the 20th century came to a close, more change came to the islands. New people arrived, seeking a simpler, less hectic lifestyle. New homes were built, including this one atop the World War II mine casemate on Peaks Island. It commands a sweeping view of Hussey Sound. (Author's collection.)

This new home on the south shore of Peaks Island is representative of the large contemporary homes appearing on the islands in the latter decades of the 20th century. (Author's collection.)

The 5th Maine Regiment Memorial Hall stands as a memorial to the men and women who sacrificed to preserve the Union during the dark days of the Civil War. It has been restored by island volunteers and now serves as a museum of Maine Civil War and Peaks Island history, as well as a cultural center for the community. (5th Maine Regiment Museum collection.)

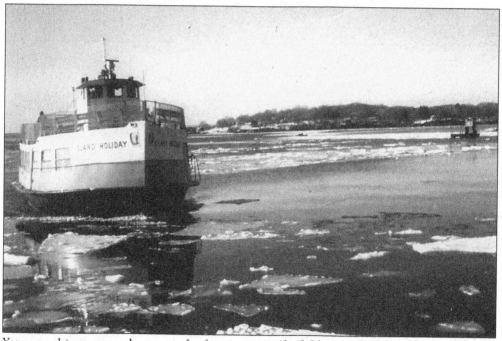

Yet some things never change, as the ferries remain the lifeline to the islands. Wooden, coal-fired vessels have given way to steel, diesel-driven vessels such as the *Island Holiday*, seen cruising past Little Diamond Island, through the ice floes common in the bay during the winter. (Author's collection.)

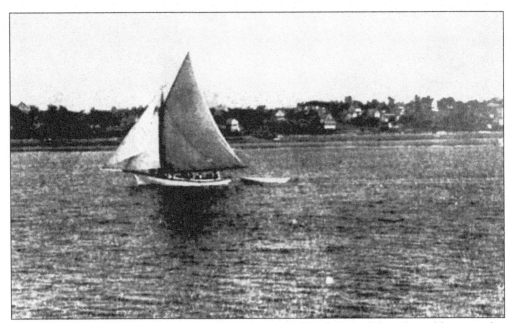

Wind-driven vessels continue to ply the waters of the bay during all but the coldest months. (Author's collection.)

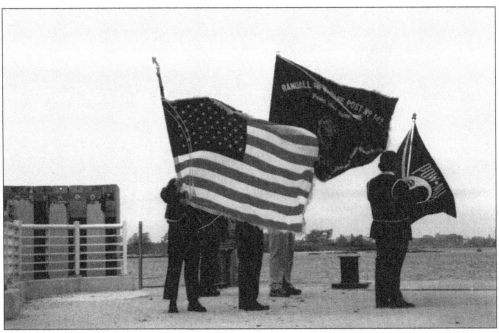

The Randall-MacVane Post honors island veterans every Memorial Day with a ceremony at Forest City Landing on Peaks Island. (Author's collection.)

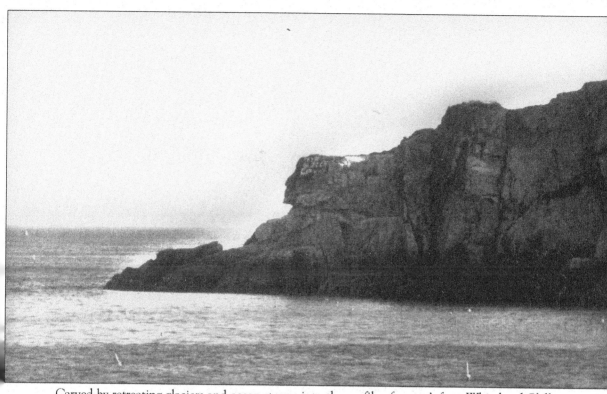

Carved by retreating glaciers and ocean storms into the profile of a man's face, Whitehead Cliff has guarded the entrance to Whitehead Passage between Cushing and Peaks Islands for thousands of years. Whitehead surely embodies the enduring character of the island people—strong, sturdy, and able to adapt to change while remaining firmly rooted in the past. (Author's collection.)

REFERENCES

Caldwell, Bill. *Islands of Maine*. Portland, Maine: Guy Gannett Publishing Company, 1981.

Crowley & Lunt. *Casco Bay Directory 1927–28*. Portland, Maine: 1928.

Dunn, William. *Casco Bay Steamboat Album*. Camden, Maine: Down East Enterprise Inc., 1969.

Elwell, Edward H. *Portland and Vicinity*. Portland, Maine: W. S. Jones, 1876.

5th Maine Regiment Museum Archives. Peaks Island, Maine: 1888–2004.

Frappier, Capt. William J. *Steamboat Yesterdays on Casco Bay*. Toronto, Canada: Stoddart Publishing Company, Ltd., 1993.

Goold, Nathan. *A History of Peaks and House Islands*. Portland, Maine: Lakeside Press, 1897.

MacIsaac, Kimberly A. *The Golden Age of Peaks 1880–1920*. Peaks Island, Maine: unpublished thesis, 1994.

Millinger, Jim. *The Nellie Gs of Casco Bay*. Yarmouth, Maine: privately published, 1993.

Moulton, John K. *An Informal History of Four Islands: Cushing, House, Little Diamond, Great Diamond*. Yarmouth, Maine: privately published, 1991.

Smith, Philip Mason. *Confederates Downeast*. Portland, Maine: The Provincial Press, 1985.

South Portland-Cape Elizabeth Historical Society. *History of South Portland, Maine*. Privately published, 1995.

Sweetser, Phyllis Sturdivant, Ed. *Cumberland, Maine in Four Centuries*. Cumberland, Maine: Town of Cumberland, 1976.

Wallace, Katherine Stewart. *Peaks Island As It Was*. Peaks Island, Maine: privately published, 1962.